BAYOU
ST. JOHN

BAYOU
ST. JOHN
•A BRIEF HISTORY•

CASSIE PRUYN

THE
History
PRESS

Published by The History Press
Charleston, SC
www.historypress.net

Front cover, top: Bayou St. John. *Frank B. Moore Collection, Earl K. Long Library, University of New Orleans.*

First published 2017

Manufactured in the United States

ISBN 9781467135214

Library of Congress Control Number: 2017948520

Water is H_2O, hydrogen two parts, oxygen one,
but there is also a third thing, that makes it water
and nobody knows what that is.

—Pansies, *D.H. Lawrence*

———•———

To the people of New Orleans

CONTENTS

Introduction 9

1. Water Before Time: Prehistory–1699
Bayou Beginnings 13
Indigenous Communities in the New Orleans Area 18

2. Bayou St. John and the Birth of a City: 1699–1804
French Discovery and Settlement 27
Development 34
Spanish Rule 43

3. Industry and Pleasure Gardens: 1804–1900
Bayou St. John, Officially American 49
Recreational Renaissance 55
The Bayou in the Civil War 61
Expansion 62

4. Bayou St John Aquatic Park: 1900–1950
Houseboats and Lawsuits 71
New Beginning, Same Questions 83
World War II 90

CONTENTS

5. BAYOU ST. JOHN IN THE MODERN ERA: 1950–2017

Subdivisions, Subdivisions 93
Roadway vs. High-Rise 102
Hurricane Katrina 106
Bayou of the Future 113

Notes 117
Selected Bibliography 129
Index 137
About the Author 143

INTRODUCTION

Gray bridge, silver guardrails. A palm tree. Oak trees along the bank. A billowing thicket of ornamental grasses. Clouds so white they're almost pearlescent. A kayaker in a red shirt, yellow boat, black paddle. Cars bunching along Carrollton Avenue. A speckled dog swimming. A ledge of cement along the shoreline, crumbling in places. Whir of a passing cyclist. Music drifting. Young people in shorts and floral sundresses, spreading a blanket. Ducks gliding by, creating a tiny, triangular wake. Houses with reddish roofs and jutting dormers. And the water—a blue-brown expanse of subtle textures, riffling in the breeze.

On any given day, standing at the intersection of Esplanade Avenue and Moss Street in New Orleans, this is what you might see. This kind of panorama is one only a body of water could create. This feeling of approaching the bayou—from Esplanade, or Bell Street, or Dumaine—and finally coming upon the blue-brown swath of it: this is what drew me to this project. The moment of arrival at the water's edge. That, and remembering some of my favorite writers, favorites because they manage to evoke a strong sense of place in their work. Through words alone, they manage to transport you. You can feel whatever place they're describing as if you're standing there yourself. Take, for example, the Nova Scotian landscape (not entirely different from my native landscape of Maine) described through the frame of a bus window in Elizabeth Bishop's poem "The Moose":

...on red, gravelly roads,
down rows of sugar maples,
past clapboard farmhouses
and neat, clapboard churches,
bleached, ridged as clamshells,
past twin silver birches....[1]

Or her poem "Song for the Rainy Season," which takes place in Brazil:

In a dim age
of water
the brook sings loud
from a rib cage
of giant fern; vapor
climbs up the thick growth
effortlessly, turns back,
holding them both,
house and rock,
in a private cloud.[2]

I love traveling back and forth with this poet—north to south and back again—and with other writers who engage with place. This is all to say that sense of place has always been important to me. It is a key reason why I was drawn to New Orleans, as a resident and as a writer. The history of this city, so tied up in the properties of the watery land beneath it, is both fascinating and visceral. I, too, wanted to try my hand at evoking place through language—not through poetry, in this case, but through the powerful medium of narrative history.

This narrative history of Bayou St. John is different from any history of the waterway that's come before. For one thing, it's comprehensive. Other sources may have focused on a particular period in the bayou's story, but none has sought to trace its trajectory from prehistory to the present day. Bits of the bayou's past have been featured in other histories of New Orleans, or else in works of memoir, but the whole history had yet to be put down in one place. This narrative also seeks to go beyond a simple retrospective of past happenings on and along the waterway. It seeks to ask deeper questions about the city's relationship to the bayou and to synthesize themes surrounding use, control and water rights with the events that have taken place along its shores. For the past two and a half years, I have put in hundreds of hours

scouring collections, engaging in conversations, finding patterns, making connections and cross-checking. At every turn, I have attempted to remain neutral on the issues and the people involved in the uses of this beloved waterway and to write a history deserving of the nuanced, complex and wonderful city that surrounds it.

But no history can encompass all there is to know about a subject, and this one is no exception. Future researchers may wish to delve into details that weren't meant for this particular project but might be well suited to another one. The bayou's many jurisdictional layers, and the tangled legal ramifications, in particular, following the 1907 termination of the Carondelet Canal and Navigation Company's charter to operate commercially on the bayou; the Library of Congress's newspaper database, "Chronicling America," with its treasure-trove of "Bayou St. John" mentions—tens of thousands of mentions, far more than I was able to read through; or the lost Bayou St. John cemetery, for example, would likely have much to offer future researchers with the time, passion and know-how to dive in.

Of course, this book and its conceit relied heavily—in terms of both inspiration and information—on great works of New Orleans history that have come before. For this, I am indebted to some of the region's best scholars and historians—Lawrence Powell, Tristram R. Kidder, Roger T. Saucier, Gwendolyn Midlo Hall, Jerah Johnson, Daniel H. Usner Jr., Lake Douglas, Edna Freiberg and especially Richard Campanella, whose geographic histories of the city have inspired both my poetry and my Bayou St. John research. My gratitude, as well, to the archivists and staff of the New Orleans Public Library Louisiana Division, in particular Yvonne Loiselle; Louisiana and Special Collections at the University of New Orleans, in particular Connie Phelps; the Notorial Archives Research Center, in particular Siva Blake; the Historic New Orleans Collection's Williams Research Center; and the Louisiana Research Collection at Tulane University, in particular Andrew Mullins. Thank you, also, to the various experts who took the time to correspond with me over the last two years, most notably Kathleen Agnew Ward, Joseph Makkos, Benjamin Maygarden, Sophie Harris, Harry Vorhoff, John Lopez, Dr. Ryan Gray, Vicki A. Mayer, Andrea P. White, Matthew Weigel, Nathanael Heller, Andrew Baker and especially Mark Davis. The specialized knowledge you shared with me enhanced the quality of this project in ways that cannot be measured.

This book is also deeply indebted to the residents of New Orleans (and beyond), for their time and energy, for all they had to teach me and for the generosity they showed me and the project at every turn—most notably,

Conrad Abadie, Jessie Borrello, Cullen Landry, Norman Nail, Franco Valentino, Anthony Favre, Jared Zeller, Joan Ellen Young, William Abbott, Linda Burns, Gay Leonhardt, Charlotte and Tom Collins, Glenn Gaudet, Norma Kimble, Peggy Laborde, Lorraine Terranova, Jennifer Farwell, Brian Boyles, Kevin Centanni, Stephanie Bruno, members of the Faubourg St. John Neighborhood Association, Janice Manuel, Gloria Martin, Audrey Evans, Dawn Fowler, Macon Fry, Phil Costa and Raymond Boudreaux. Thank you, too, to all the friends and acquaintances who threw bayou tips my way over the course of the project—this book has benefited greatly from your collaboration and sense of community.

Finally, my immense gratitude to Candice Lawrence of The History Press, who was quick to answer each and every question and whose calm enthusiasm and expertise helped me feel grounded throughout the project. Thank you to Kelley Crawford of *NolaVie* for always believing in the project and for helping spread the bayou word. Thank you, most of all, to Benjamin Morris, without whose mentorship and generosity this book would not exist. Thank you, as always, to my loving and supportive family, who are always on the sidelines cheering me on. Thank you to Lauren Gauthier, my wife and unofficial agent, for always listening to me—whether I was rambling on about bayou fun facts or else weeping out of fatigue, you have been the most wonderful partner in every sense of the word. Thank you, above all, to the city of New Orleans—for inviting me in, for inspiring me and for providing endless stories of perseverance, whimsy, darkness and *joie de vivre*.

In conclusion, the stories of waterways are nothing less than the stories of human civilization. In our modern times, sometimes we forget just how important waterways—particularly navigable ones—were to the development of our cities. New Orleans provides us with a particularly rich example of this truth. And as I write this on the cusp of the city's Tricentennial, water is becoming acutely relevant again as the city strives to position itself for a sustainable future. Water is dynamic; our relationship to water is dynamic. Given all of this, what can we learn from our Bayou St. John? What can it teach us as a public asset, a post-commercial corridor, a recreational haven, a recuperating ecosystem? What can it teach us about the past and, consequently, the future? My hope is that this book begins to answer these questions.

1

WATER BEFORE TIME

Prehistory–1699

BAYOU BEGINNINGS

The longest river on the continent. Hot, fetid swamps full of danger. A continuous struggle between the forces of land and water. To separate the human history from the geographic history of New Orleans is impossible. Occupation of this ever-shifting slab of river-spewed land has required ingenious methods of adaptation, which in turn have affected all aspects of human development. For this reason, to tell the story of how Bayou St. John came to be, and how the city of New Orleans came to grow up around it, we must start long before the city was even a dream. A brief geology lesson is in order.

When the planet warmed after the last glacial period, approximately eleven thousand years ago, ice sheets coating the North American continent began to melt. Sediment-laden meltwater gushed from all corners of the landmass, converging in its midsection and crashing into the ancient Gulf of Mexico, which stretched as far north as present-day Illinois. As geographer Richard Campanella puts it, "When moving water laden with sediment suddenly hits a slack water body, it loses its kinetic energy and dumps its sediment load."[3] Dirt culled from across the continent began accumulating along the floor of the embayment—over one thousand cubic miles of dirt, when all was said and done—pushing the gulf southward, advancing in plumes, creating and extending the coast.[4]

During a flood, any active alluvial river spreads sediment across the land. It drops the coarsest, heaviest grains first and distributes the finer stuff farther out, eventually lifting itself above the surrounding floodplain on a ridge of its own making. Because of this unique land-building process, an alluvial river must at some point escape its own elevation and find a more efficient route to the sea: it ruptures its bank in a place of least resistance, an event called a *crevasse*, and surges off in another direction to begin a new lobe, starting the land-building process all over again. Eventually, that abandoned lobe, now starved for sediment, begins to sink back into the sea. Often an alluvial river will build several lobes at once, snaking across the deltaic plain as gravity dictates.[5] Historian Lawrence Powell offers an analogy: "As the serpentine Mississippi strove to shorten its distance to the sea, it slithered across its lower floodplain like a garden hose that had been turned on high and dropped accidentally on the lawn."[6]

One of the most important channels of the Mississippi River to have coursed through the New Orleans area is called the Metairie-Sauvage distributary. It broke off from the main trunk of the river approximately two thousand years ago around present-day Kenner and stretched along the path of what is now Metairie Road, City Park Avenue, Gentilly Boulevard and Chef Menteur Highway.[7] Considered the earliest of the St. Bernard Delta distributaries, our Metairie-Sauvage channel was active—as in, still receiving significant feed from the Mississippi—until about seven hundred years ago and, at the height of its activity, was approximately one thousand feet wide at its widest and about fifty feet deep at its deepest.[8] It coursed progressively northeastward along the southern rim of present-day Lake Pontchartrain, guided by a chain of ancient barrier islands, and emptied into what is now Lake Borgne.[9] The distributary eventually plugged up all the spaces in that island chain with its sediment and, in so doing, swept up a small swath of the sea (Lake Pontchartrain) as if holding it in the crook of its arm.

In exploring the connection between this distributary and the creation of Bayou St. John, one might first wish to know: what exactly *is* a bayou? Historian Edna Freiberg offers a succinct definition of the feature: "A bayou is a finger of a larger body of water, but, unlike a river, flows from, not into, the connecting waterbody. Bayous have little current of their own except that induced by connecting streams, heavy rainfall, wind or flooding; their waters rise, fall and flow back and forth according to the condition of the parent body."[10] Geologist Roger T. Saucier adds that the sluggish streams typically meander enthusiastically across the landscape and may be fed by several small tributaries. Our bayou responds to its parent body of water,

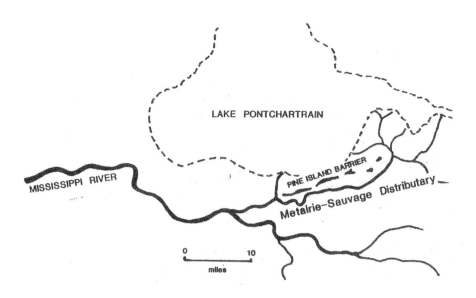

Metairie-Sauvage distributary coursing along the southern rim of Lake Pontchartrain. *From "Ecology of Bayou St. John: A Thesis," Kathleen Agnew Ward, University of New Orleans.*

Lake Pontchartrain, which is in turn affected by tides and wind and has also historically responded to the surrounding landscape by serving as a drainage outlet.[11]

Almost certainly, the Metairie-Sauvage distributary spawned Bayou St. John. An arm of excess water that needed to escape, the would-be bayou busted through the channel's natural levee and dug itself a bed out to Lake Pontchartrain. Theories differ as to when this crevasse event initially occurred, however—whether the Metairie-Sauvage channel was active or "abandoned" itself by the time Bayou St. John broke loose. Campanella summarizes the first theory that suggests that it formed when the distributary was still active:

> *Bayou St. John is the sibling of the Esplanade Ridge, offspring of the the same former channel of the Mississippi River* [the Metairie-Sauvage distributary] *that once flowed along the Metairie/Gentilly Ridge....*[I]*t is theorized that this channel formed a sharp meander near the present-day entrance to City Park, before continuing eastward. At one point in the meander, a distributary was released southward to form the Esplanade Ridge. At another, a smaller distributary broke off northward, becoming Bayou St. John.*[12]

Today's bayou is the only remaining visual clue of the Metairie-Sauvage distributary's unexplained swerve in this location—where it trifurcated into Bayou St. John, what would later become Bayou Sauvage, and the stream that formed our present-day Esplanade Ridge, referred to simply as "Unknown Bayou" in geological literature.[13]

Here's another theory: by about seven hundred years ago, the Mississippi River had stopped feeding the Metairie-Sauvage distributary in any significant way.[14] Once abandoned, the channel partially filled in with silt and sand and slowed into a network of sluggish bayous—most notably, Bayou Metairie and Bayou Sauvage (or Gentilly).[15] The Mississippi River, having swung into the path it presently occupies, began building its natural levees to the south. As its levees began to grow, a segment of its eastern levee encroached on those of the former Metairie-Sauvage channel, filling in part of bayou system around the intersection of present-day Broad Street and Orleans Avenue and creating two shallow "bowls," one to the east and one to the west.[16]

The second theory holds that the bayou formed as the primary drainage outlet for the western bowl. Powell explains that "[f]ollowing heavy rainfalls and storm surges from the Gulf, a small lagoon used to pond up in the saucer-like depression between Metairie Ridge and the river. Bayou St. John…is actually a tidal creek that geological processes notched midway through the ridge to allow the impounded rainwater to drain off toward the lake."[17] After a few larger floods, this modest channel would have been sufficiently well established to begin carrying all the water it received northward toward the lake, even during times of low water.[18] The bayou also began bleeding southward, splitting into several fingers that reached nearly all the way to the present-day Mississippi's natural levees.[19] Campanella explains:

> *Because of its short distance, its isolation from the new channel of the Mississippi, its minute sediment load, and the tidal effects of the lake, Bayou St. John never formed natural levees [itself]. Rather, it was a narrow, clogged, slack-water inlet through which tidally influenced brackish lake water intruded into the marshes.*[20]

Like any good story, then, aspects of the bayou's origins remain shrouded in mystery. Yet its future use for the people who would soon call this corner of the coast home is just as interesting as theories about when it was formed. The bayou connects the area's oceanic past (Lake Pontchartrain) with the

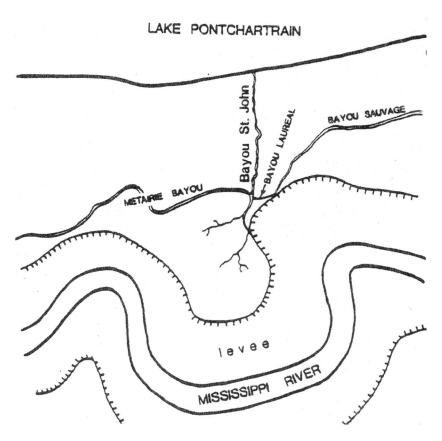

Eastern levee of the Mississippi River encroaching upon those of the Metairie-Sauvage distributary. *From "Ecology of Bayou St. John: A Thesis," Kathleen Agnew Ward, University of New Orleans.*

alluvial forces that changed it forever (the Metairie-Sauvage distributary), forming a conduit between a piece of ancient sea and remnants of the delta that bloomed over it. Because of these properties, it also formed a crucial link in a transportation corridor that avoided the treacherous mouth of the Mississippi. Indeed, the bayou's topographical significance within this low-lying landscape cannot be overstated and is key to understanding its role in determining the site of the future city of New Orleans. This much is well known. But what is less well known is the fact that long before the French utilized this "backdoor" route the bayou helped facilitate, native populations across the region were using it in not dissimilar ways.

Indigenous Communities in the New Orleans Area

Between the moment when Hernando de Soto became the first documented European to cross the Mississippi River in 1541 and the arrival of the French in the 1670s, Native American life in the area of future Louisiana changed dramatically. Even with the modest contact between de Soto's crew and the tribes he encountered, European diseases ravaged native populations in subsequent years. Historians suspect this epidemic meant tribes were moving about the region in patterns they had not previously employed, perhaps in part to avoid older living sites that were potentially infected. Moreover, whenever populations experience demographic devastation at this level, cultural superstructures are the first to collapse. Given these factors, the political and religious systems that had been evolving within native populations of Louisiana for thousands of years were, by the time the French arrived on the coast, a mere shadow of what they had been.[21] And yet the accounts of early French explorers make up much of the only written primary evidence that remains. For these reasons, historians differentiate between "pre-contact" and "post-contact" native life. Almost everything we know, unfortunately, dates from the latter.

We do have the accounts of de Soto's crew, which enable rough guesses about the crew's course through the region and some of the Native American tribes they encountered along the way. They are rife with biases and inaccuracies, however, like many of the European accounts to follow, particularly when it comes to descriptions of native life—such as exact locations of tribes or tribal demarcations, let alone more detailed observations of culture or customs.[22] Archaeological evidence, which can fill in the gaps of European accounts, is also hugely incomplete, particularly in the New Orleans area.[23] The little evidence that remains, however, helps illustrate broad patterns in pre-contact native life, particularly when considered alongside the properties of the landscape.

Many archaeological sites in the Pontchartrain Basin take the form of shell middens in varying states of integrity. The vast majority have been mined and redistributed for the paving of roads and other construction projects, but the few that remain have proven very useful in teaching us about the past.[24] Shell middens are irregular heaps primarily composed of discarded mollusk shells, as well as animal bones, pottery sherds and man-made tools. They typically take the form of long, narrow ridges or beaded chains, occasionally up to several hundred feet long and fifty to one hundred feet wide.[25] One

man's trash is another man's treasure; because they include items indigenous people used in their everyday lives, they are archaeologically valuable. Mollusk shells, for example, can tell us about salinity levels and temperatures of nearby bodies of water at the time of their consumption.[26] Pottery helps us date the middens, and animal bones and tools tell us about indigenous subsistence habits. Often, middens in this landscape are announced by the unique flora found growing on top of them—most notably stands of live oak trees—and because of their greater height in relation to the surrounding, often tree-less marsh.[27] Archaeologist Tristram R. Kidder explains:

> *The early colonists noted the abundant stands of oak in the* [present-day New Orleans] *region. The Trudeau map of 1803 plots the location of these stands, making special mention of their economic potential. The distribution of these stands of oak parallels exactly the distribution of Native American shell middens. Other examples include the distribution of shell middens along Bayou Barataria, the Lakefront, and Metairie and Gentilly ridges, to name a few.*[28]

The Big Oak, Little Oak and Little Woods Islands in eastern New Orleans still exemplify this today, rising above the surrounding marsh like little hardwood mohawks.[29]

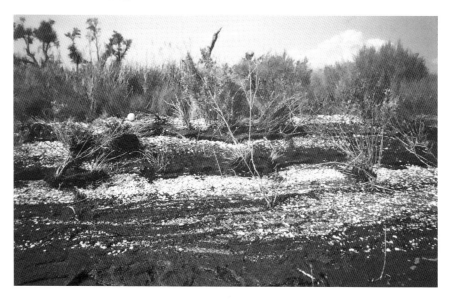

Remnants of a prehistoric shell midden in St. Bernard Parish, destroyed by shoreline erosion. *Courtesy of the U.S. Army Corps of Engineers, New Orleans District and R. Christopher Goodwin & Associates Inc.*

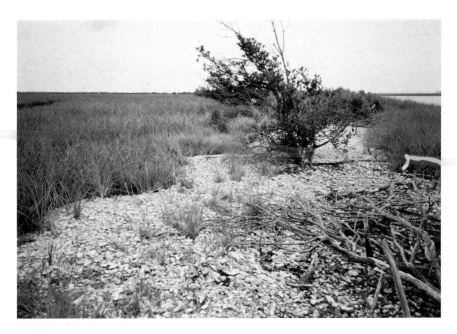

Prehistoric shell midden in the Golden Triangle Marsh in St. Bernard Parish. *Courtesy of the U.S. Army Corps of Engineers, New Orleans District and R. Christopher Goodwin & Associates Inc.*

Archaeologists divide the prehistoric occupation of southeast Louisiana into four general stages—Paleoindian, Archaic, Woodland and Mississippian—and, in turn, divide those stages into chronologically defined periods based on cultural traits and artifacts.[30] In the Pontchartrain Basin, shell middens became common during the Early Woodland period, starting around 800 BC.[31] Indigenous peoples throughout the Mississippi deltaic plain migrated in response to the swings of the river and traveled and traded extensively.[32] Given the nature of the landscape, it is surmised that most habitation sites in the Pontchartrain Basin were "satellite" camps that allowed for specialized seasonal activity—hunting or fishing, for example—in relation to a permanent village elsewhere.[33] Historian Daniel Usner writes:

> *Situated between a chain of lakes and the Mississippi, the crescent-shaped bend at what became New Orleans had been mainly used by Indians for transport between waterways and seasonal gathering of food sources. Yet natural conditions that made this site ideal for portage and fishing reduced its potential for permanent occupation.[34]*

Live oak that once grew atop an ancient midden; shells have since been hauled away. Jean Lafitte National Historic Park and Preserve. *Photo by author.*

If indigenous communities, when selecting sites for habitation, had to consider access to high ground, sources of food and fresh water and water as means of transportation, then the Pontchartrain Basin would have provided three types of areas on which to settle: the beaches of the lakes, the edge of the continental shelf called the Prairie Terrace north of Lake Pontchartrain and the natural levees of Mississippi River distributaries. "Perhaps the most frequent location of major [archaeological] sites [within the Mississippi River deltaic plain] is at the juncture of river distributaries," scientist Sherwood Gagliano tells us.[35] This was for several reasons: natural levees provide relatively high, well-drained land on which to live, as well as access to the streams that built them, enabling efficient transportation across the landscape. The main river channel would have functioned like a major highway, while the smaller streams and distributaries would have allowed access to the wildlife-rich backswamp like a series of smaller interconnecting roads.

It was not enough to know just where to live in these years; Native Americans also knew *when* to occupy these natural levees. Any kind of long-term habitation along an active alluvial stream was illogical. Instead, the

ideal time to live on the natural levee, aside from seasonal considerations, was after the stream had reached "maturity," or was no longer frequently flooding, and when the environment was therefore more stable and predictable.[36] Because of this fact, the distribution patterns of shell middens in the Pontchartrain Basin, as in all parts of the deltaic plain, are directly correlated to places where habitable, "mature" streams were located at the time of their initial deposition.[37]

How do these occupation patterns apply to the area around Bayou St. John? Usner writes:

> *Before European contact Indians used the four-to-eight-mile-wide strip of swampland* [in and around present-day New Orleans] *as a fishing/hunting/gathering station and as a portage between the lakes and the river. The most habitable sites were along Bayou St. John…and on the Metairie Ridge….From this junction* [of Bayou St. John and Bayou Metairie] *Indians reached the Mississippi by a three-mile portage.*[38]

By employing the Pontchartrain Basin lakes, Bayou St. John and the Metairie-Gentilly ridge system, Native Americans were able to reach the main channel of the modern Mississippi River without having to navigate its mouth. Communication between the Gulf, the lakes and the Mississippi would have been crucial for both trade and subsistence—providing access to multiple food sources, including brackish and fresh waterbodies as well as forested land—and Native Americans employed portage routes like the one our bayou affords to traverse the region's otherwise impassable backswamps.[39]

In 2013, the Federal Emergency Management Agency conducted an archaeological dig at the colloquially named Spanish Fort, the ruins of a colonial fort along the bayou's banks north of Robert E. Lee Boulevard. This is a junction where archaeologists had long assumed an ancient Native American site once existed, as evidenced by colonial documents, the historic location of the lakeshore and general patterns of native settlement. Beneath the fort's remains, FEMA archaeologists found animal bones, pottery sherds, fragments of clay tobacco pipes and other artifacts dating from the late Marksville period, or from around AD 300–400. Much to their surprise, investigators discovered that the French had lopped off the top of this Marksville shell midden and used it as the fort's foundation, as opposed to destroying it completely, as was previously thought.[40]

Over the coming centuries, the Spanish Fort site would also serve as a resort area and amusement park, of which the archaeologists also found evidence,

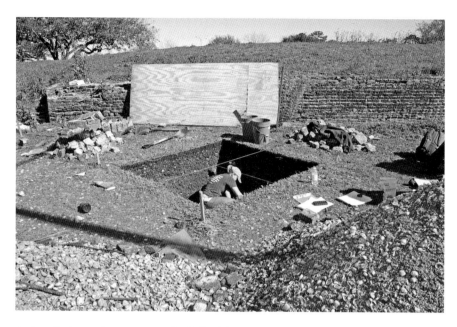

Archaeologists under contract to the Federal Emergency Management Agency (FEMA) surveying land near Bayou St. John, 2013. *National Archives.*

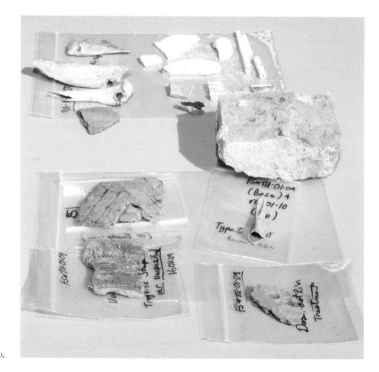

Pottery sherds, animal bones and pieces of clay tobacco pipes discovered by archaeologists at the Spanish Fort site. *National Archives.*

but we now know for certain that Native Americans lived there first, and its location at the former intersection of Lake Pontchartrain and Bayou St. John proves their awareness of this critical portage route.[41] Archaeologist Charles R. McGimsey gives us a sense of Markville-era ways of life:

> *Across the state during this interval, people were living in a wide variety of environments. Most of these communities were small villages, usually near a bayou or stream, lacking thick deposits of refuse. These data suggest to archaeologists that people did not stay in a given village for more than a few years before moving to another location. In some areas, or at some times of the year, some groups may have moved more frequently to take advantage of seasonally available resources (such as nuts, spawning fish, or clams). The people in these communities lived by hunting and gathering wild plants and animals, and they shared a common set of stone tools and ceramics.*[42]

Local researchers believe that further evidence of Native American settlements along Bayou St. John and Metairie Ridge exists, but that it may never be uncovered due to the urban development of these areas. Various historical documents attest to potential archaeological sites around where the Norfolk Southern train tracks cross Metairie Road or around the area of present-day Cabrini High School, but these claims have yet to be proven.[43] And although we can safely assume the bayou and landscape surrounding it were used by indigenous populations throughout the years, post-contact evidence, as provided by early French settlers in present-day New Orleans, is hazy in its assessment of which specific tribes lived along the bayou at the start of the colonial period. Kidder sums up what certain historical accounts suggest:

> *Iberville…mentions a Quinipissa village near or at the terminus of the portage (probably Bayou St. John), possibly in or near the modern French Quarter. A 1718 map by Guillaume Delisle shows an "Ouma" (probably Houma) settlement at the juncture of Bayou St. John and Bayou Metairie. Villiers, however, suggests that this location for the Houma is in error since they probably lived farther upstream at the time. Le Page du Pratz records that a Cola Pissas (also known as Colapissa or Acolapissa) community once occupied the same location.*[44]

Usner adds, "By 1699 a group of Acolapissas occupied Metairie ridge, but during the first decade of the eighteenth century some Biloxis and

then some Houmas moved in temporarily."[45] Local oral histories of Native American presence in the area maintain that Acolapissa and Houma tribes once lived the near where Bayou St. John and Bayou Metairie converged, with Bayogoula peoples occupying the present-day Mid-City area.[46] Until new discoveries come to light, however, details surrounding particular tribes in the region remain mysterious. Nonetheless, indigenous communities' impact on the landscape and on the people who would soon colonize it remains indisputable.

That indigenous peoples existed "in harmony" with the pristine natural world before the arrival of Europeans (who in turn tamed the landscape to make way for modern life) is a popular narrative recurrent throughout American history. This narrative is often a highly simplistic before-and-after shot of the landscape in question, with the boundary line between them—European arrival—marking the spot where history officially "begins."[47] In reality, the story is far more nuanced. Campanella summarizes:

The pre-colonial Gulf Coast and Louisiana deltaic plain comprised not the "forest primeval" romanticized in literature and popular history, but rather a landscape already transformed by sequential indigenous occupations more expansive and influential than commonly thought. The first Europeans did not "commence" history and document a benchmark landscape from which all subsequent transformations derived; they merely encountered a landscape continually under transformation—vastly by physical forces over millennia, and considerably by indigenous human forces over centuries.[48]

Campanella goes on to explain that one of the most lasting contributions the Native Americans of the region made to our future city was the transmission of key geographic insights to the early French explorers:

Through extensive travel and trading, natives mastered the region's complex labyrinth of swamps, marshes, rivers, bayous, ridge systems, and bays. They revealed to the newcomers myriad portages, shortcuts, "back doors," safe routes, resources, and foods.… "The Indians made maps of the whole country for me," reflected Iberville in 1699.[49]

Our maps might look different now, but imagination can help bring to life what the area may have looked like at this turning point in its human history.

If you could travel back to a time before the arrival of the French explorers and stand on the banks of Bayou St. John, near the spot, say, where

present-day Esplanade Avenue meets present-day Moss Street, you would find yourself in a lush prehistoric world. All around and above you, massive live oaks, pecan, acacia, wild cherry and sweet gum trees would loom. If you climbed a tree and stuck your head up through the canopy, you would see where, to the west and east of you, these mammoth trees extended along the spine of the ridge, along the center of which the slack-water remnants of the former Metairie-Sauvage distributary would still be flowing. On either side of the ridge, you could watch the land slope almost imperceptibly down, its gradient marked by a change in flora: cane brakes and thickets of palmetto blanketing the slope, dissolving into stands of cypress and swamp tupelo trees standing knee-deep in still water. If you were to look to the north of your tree-top perch, you would be able to follow the tributary-fed curves of Bayou St. John—studded with islands and sandbars, chock-full of fish and turtles and alligators—as it meandered toward the blue, midden-lined Lake Pontchartrain positively teeming with marine life. Swarming above your head, immense clouds of migratory birds, perhaps ducks or wild geese, would intermittently block out the sun. Down on the forest floor, rabbits and bears and deer would be hiding in the underbrush. Behind you, along a small ridge, a path worn smooth by the dragging of canoes, strewn on either side with satchels and other baggage, would extend in a roughly southeasterly direction toward the risen banks of the Mississippi. And if your eyes were *really* keen, you might even be able to spot the white sails of a distant French ship as it wandered among the barrier islands of the Gulf coast, searching for the Mississippi's mouth.[50]

BAYOU ST. JOHN AND THE BIRTH OF A CITY

1699–1804

If navigable waterways during prehistoric times acted much like aquatic roads across the landscape, then they facilitated literal roads during the colonial era. But this doesn't mean founding a permanent settlement atop the region's dynamic, semi-aqueous terrain was a simple task.

FRENCH DISCOVERY AND SETTLEMENT

"The lower part of the Missicipi [*sic*] is the most confounded place in the world," French explorer Étienne de Veniard, Sieur de Bourgmont, remarked in his 1714 *Exact Description of Louisiana.*[51] Swathes of brown water billowing into blue. Pressurized mud shooting above the water's surface and hardening like tree trunks. Land so fluid it could barely hold a man's weight. Once European explorers were finally able to *locate* the mouth of the Mississippi—which was notoriously tricky to discern, hidden among the mesh of streams and bayous coursing along the Gulf coast—they realized how difficult ascending it would be. Hurtling refuse, shifting sandbars, varying winds. Mellifluous banks that, as Bourgmont writes, were nothing more than "drowned meadows."[52] Ascending the maw of the great Father of Rivers, from European exploration until the age of the steamboat, was nothing short of harrowing.[53]

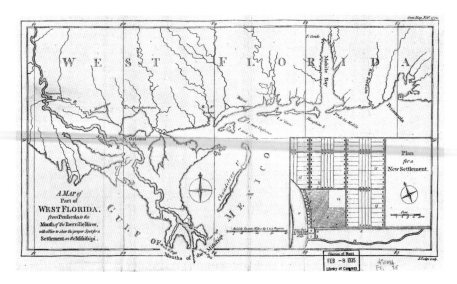

"Map of part of West Florida: from Pensacola to the mouth of the Iberville River, with a view to shew the proper spot for a settlement on the Mississippi," 1772. *Library of Congress.*

And yet a permanent presence along the lower Mississippi was crucial for the French. Control of the continent's greatest artery would mean virtual domination, from the St. Lawrence River south to the Gulf. If they didn't claim it, England or Spain would. So an expedition under the leadership of Pierre Le Moyne, Sieur d'Iberville, a Canadian naval officer, and his younger brother Jean-Baptiste Le Moyne, Sieur de Bienville, was dispatched in the fall of 1698. They were commanded to find "the mouth…select a good site that can be defended with a few men, and block entry to the river by other nations."[54] They indeed eventually stumbled on the Mississippi's gushing mouth. And with the help of natives they encountered on their journey upriver, they would soon discover a critical shortcut that would allow them to avoid it.[55]

Iberville, in detailing his first trip up the Mississippi, wrote:

> *Two leagues from the place where we stopped for the night, the Indian I have with me pointed out to me the place through which the Indians make their portage to this river from the back of the bay where the ships are anchored* [near present-day Ship Island]. *They drag their canoes over a rather good road, at which we found several pieces of baggage owned by men that were going there or were returning.*[56]

There is significant confusion surrounding the exact location of the portage route Iberville was shown in 1699. It could have been a bayou-ridge formation in St. Charles Parish, near the present-day Bonnet Carré Spillway, or it could have been the Bayou St. John/Esplanade Ridge. The confusion speaks to both repetitions in the landscape (the relict welts of the Mississippi's former wanderings) and the parallel use of such formations by indigenous communities. The portage—whichever it was—allowed travelers to enter Lakes Borgne and Pontchartrain from the Gulf, to descend as far as possible along a smaller waterway (like Bayou St. John) toward the river and to travel overland to the Mississippi's bank from there, thereby eliminating the need to ascend the river's mouth in order to effectively stake a claim to its entirety.

The portage route was recognized by the brothers as an efficient trade corridor, but they did not immediately consider it a potential site for permanent settlement. In short, it was too wet. Father Paul du Ru, who accompanied Iberville on his second visit to the portage in January 1700, wrote, "From the head of that little river [Bayou St. John?], we must cross through woods but on a path where there is water up to one's waist and mud to one's knees."[57] For the better part of the next two decades, colonists and officials would vigorously debate the proper site for the Company of the West's headquarters. Bienville, governing the colony after his brother's death, would eventually pick the site *for* them, for reasons that were never entirely clear. Regardless of which portage the brothers had been shown first, Bienville was well aware of the Bayou St. John/Esplanade Ridge route by the time New Orleans was founded. In fact, it was one of the only advantages, however wet, the site of the future city could boast.[58]

Like a good French Canadian at the turn of the eighteenth century, Iberville began establishing friendly relations with the nearby native populations as soon as he arrived in the area. He visited tribes to build alliances and attempted to calm intertribal conflict in an effort to create a united front against the English. In order to foster continuous contact between the two groups, French forts were built in proximity to Native American villages. Tribes displaced and depopulated by disease and warfare were moved to new settlements close to the French. According to Usner, at the same time that the struggling colony needed Native American expertise in order to grow food and navigate the landscape, Native American tribes, weakened by disease, needed protection against British expansionism and so were often quick to ally themselves with the French.[59]

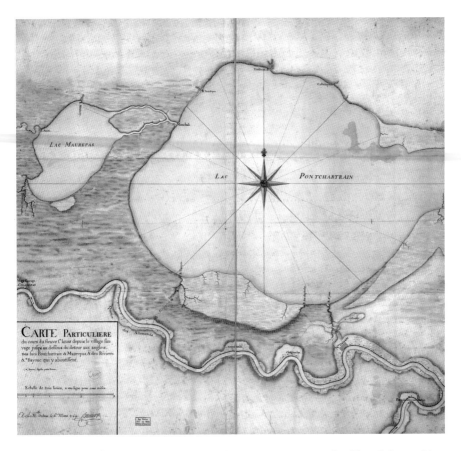

A 1749 French map, with Bayou St. John and portage route connecting New Orleans with Lake Pontchartrain. *Library of Congress.*

A full decade before Bienville's men began felling trees along the present-day French Quarter riverbank—indeed, before the current site of New Orleans was even considered for the colony's main settlement—Bayou St. John witnessed an example of these shifting regional alliances. In 1708, Louisiana's colonial population, numbering fewer than three hundred souls, was essentially starving, relying entirely on the local native peoples for food. As an agricultural experiment, eight Canadians living in Mobile were persuaded to move to the banks of Bayou St. John, near where a group of Biloxi natives had been relocated several years earlier, in order to attempt to grow wheat with the help of Biloxi slave labor. They were granted concessions for their crop—long, slender ribbons stretching from the bayou's east bank toward Bayou Sauvage, between present-

day Esplanade and Orleans Avenues—but despite a strong start, the wheat ultimately withered in the springtime heat. Of the eight original landowners, only one remained by the time New Orleans was founded in 1718: Antoine Rivard, who came to the bayou in 1708 with his wife and child, would soon become, after buying up a few of the concessions left behind, the earliest large property owner on the bayou.[60]

The years surrounding the Company of the West's 1717 directive to found New Orleans as the colony's capital settlement were defined by fierce debate. Many colonists and company officials were pushing for present-day Manchac instead. Manchac was less subject to flooding, closer to the colony's proposed center of agricultural activity and presumably accessible through the same shortcut method future New Orleans would be. Some other potential sites included Natchez, Biloxi, Mobile and Pensacola.[61] According to Powell:

> *Why Bienville selected the river crescent as the place to build the principal town of a revamped colony is really a matter of conjecture. It wasn't a choice he had been mulling over for months or years. It feels more like a spur of the moment decision....If geography had a bearing on where New Orleans wound up, geography was not destiny.*[62]

Nonetheless, in the spring of 1718, Bienville led a group of men via the portage route to the riverbank of the present-day French Quarter and began clearing the forest, despite lacking any official authority to do so. Simultaneously, he began offering land and slaves to those who would agree to settle nearby. Soon enough, prospective settlers were trickling down Bayou St. John in flatboats and portaging along the ridge to the riverbank, selecting sites for their future homes along the way.[63] One of these early settlers was twenty-three-year-old Antoine-Simon Le Page du Pratz, considered one of Louisiana's first historians, who slipped down the bayou in early 1719 and later wrote of his experience living for a short time along its banks.[64]

Du Pratz's *Histoire de la Louisiane* (1758) describes massive carp in Lake Pontchartrain, the modest fort built at the bayou's mouth (where remains of Spanish Fort reside now) and the planters along the banks of the southern end of Bayou St. John and Bayou Sauvage, among many other details about the developing town. Of his voyage from the Gulf to the base of the bayou, du Pratz wrote:

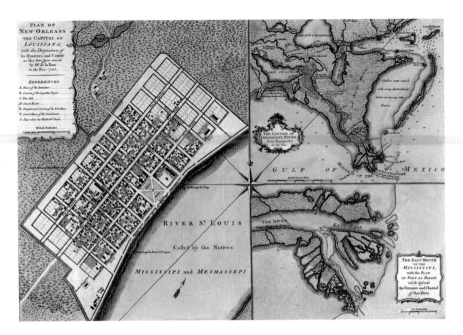

New Orleans, shown with the mouth of the Mississippi and lakes, with Bayou Road snaking off through the swamp, circa 1720. *Library of Congress.*

We entered this Creek Choupic [Bayou St. John]: *at the entrance of which is a fort at present. We went up this creek for the space of a league, and landed at a place where formerly stood the village of the natives, who are called Cola-Pissas, an appellation corrupted by the French, the true name of that nation being Aquelou-Pissas, that is, the nation of men that hear and see. From this place to New Orleans, and the river Mississippi, on which that capital is built, the distance is only a league.*[65]

Du Pratz and his men spent a few nights in huts left behind by the Acolapissa tribe along present-day City Park Avenue, land then owned by Rivard. Du Pratz described the Chitimacha slave woman he purchased soon after arriving "in order to have a person who could dress our victuals" and with whom he communicated using crude sign language.[66] Although he was pleased with the habitation he ended up building along the bayou nearby, he was ultimately convinced by General Commissioner Marc-Antoine Hubert, one of Bienville's main antagonists in the fight for New Orleans as capital, to relocate to Natchez. Hubert sweetened the deal with land and slaves, and even du Pratz's Chitimacha slave, who expressed the

desire to relocate with him, had the distant settlement's praises to sing: "The sky is much finer there; game is in much greater plenty."[67] After about two years on the edge of the bayou, du Pratz and his Chitimacha slave (whose name he never shares) moved to Natchez. He ultimately returned to France in 1734 after sixteen years in the colony, and his *Histoire de la Louisiane* remains a fascinating resource on early colonial life around and along the Mississippi River.[68]

Despite its detractors, New Orleans continued to grow. By 1721, there were 461 inhabitants living in the French Quarter and 446 inhabitants spread throughout the nascent plantation districts located along the city's outer ridges, along Bayou St. John, Bayou Metairie and Bayou Sauvage.[69] In contrast to typical European settlement patterns in North America at the time, where plantations were often scattered a considerable distance from towns, Powell tells us that "just the opposite was the case in the New Orleans region, where plantations seemed more like an extension of urban life."[70] Bayou St. John and its slender, radiating plantations exemplified this spatial reality, with the portage route (present-day Bayou Road) as the all-important connecting

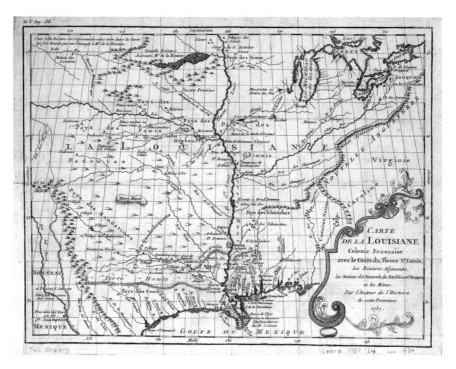

Map of the Louisiana Colony, by Antoine-Simon Le Page du Pratz, 1758. *Library of Congress.*

thread to the city. This proximity to rural settlements, together with the surrounding swamps, had many implications for the town—impacting trade, development and interactions between its inhabitants.

In 1719, the first enslaved Africans arrived in New Orleans. As soon as they arrived, they were put to work clearing forest, cultivating land and building the town's early infrastructure—in short, making this volatile town viable. The colony was also in desperate need of their skills as artisans and farmers. Yet much to the chagrin of local slave owners, New Orleans' permeable backswamp allowed for the movement and intermingling of the city's residents, enslaved and free, as no other ecology could. Its liquid wilderness was ideal for secretive travel (running away) and "unacceptable" alliances (say, between Native Americans and slaves) and prevented the boundaries between groups of inhabitants from ever fully solidifying. Bayou St. John, dribbling through swampy cypress forest from Metairie Ridge to the lake, was a prime example of the type of setting in which these nuanced dynamics would unfold.[71]

DEVELOPMENT

Within a few years of the settlement's founding in 1718, landowners along Bayou St. John and Bayou Sauvage began making their mark on the developing town. In another example of Bienville giving land to friends and allies who would agree to stay, the Dreux brothers—Mathurin and Pierre—received slaves and well-situated concessions along the Bayou Sauvage ridge. They named their acreage "Gentilly," after the Paris estate from which they hailed, and from that time forward, Bayou Sauvage came to be known as Bayou Gentilly. The brothers soon began producing timber and bricks and raising cattle, and by 1730, they were operating a brewery that served as a popular spot for "promenades."[72] Marc-Antoine Caillot, a young clerk for the Company of the Indies (the Company of the West became the Company of the Indies in 1719), wrote of the Dreux brothers' brewery:

> At a quarter of a league downriver, there is a brewhouse that functions as a place of recreation for taking promenades, and at this place you can also drink this beer that is brewed with roasted maize, also known as Turkish wheat. It is not one of the best, but when wine is lacking, it is good. This place has the feel of an open-air café in Paris.[73]

A residence along Bayou Gentilly in 1836, reminiscent of those from the previous century. *Pilié, Louis Joseph. Plan Book 84, folio 7, (084.007), August 26, 1836. Courtesy of Dale N. Atkins, Clerk of Civil District Court, Parish of Orleans.*

Claude Joseph Villars Dubreuil, who would later become the city's contractor of public works, was also granted a large piece of land along the bayou in 1719, stretching from around present-day DeSaix Avenue to around the present-day Wisner Overpass. By the end of his career, he was considered by some to be the richest planter in French Louisiana, owning around five hundred slaves.[74]

The 1721 census shows planters along Bayou St. John had more wealth than the average New Orleans resident, with Rivard, our 1708 holdover, taking the blue ribbon for most slaves owned, both African and Native American. In 1724, a report sent to the Company of the Indies confirmed that early Bayou St. John planters were prospering: "This bayou is established by four settlers, the least of whom has eight to ten Negroes, and each has very fine land. Next year these settlers will no doubt raise a quantity of indigo, having had this year a supply of grain; and though their land is only a league back of New Orleans, it is not subject to inundation."[75]

As for the other end of the bayou, travelers to the city around this time reported plantations, orchards and several dozen small houses occupied by fishermen near the bayou's intersection with Lake Pontchartrain. Surrounding these structures, in contrast to the forested ridge comprising the bayou's southernmost section, were cypress forests, marshy prairies and brackish lake stretching as far as the eye could see. A tavern and restaurant served the community of fishermen and the men stationed at the fort.[76] Orange, plum, pear and banana trees stretched in rows along the lakeshore.[77]

Although Bayou Manchac, farther upriver, was often used as a means of transporting goods to the new town, a 1721 report to the Company of the Indies says it was dry at least half the year and that most shipments (including smuggled goods) came in via Bayou St. John. In order to house and protect these supplies, a warehouse (*masasin du roi*, or the "King's warehouse") was built at the intersection of the portage path and the bayou. This spot, called

35

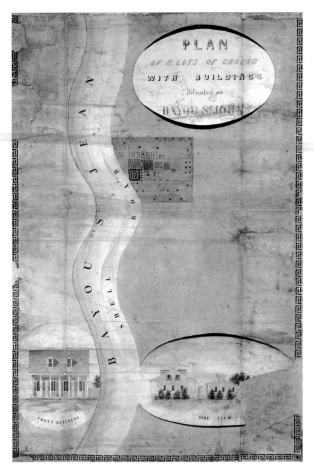

Left: A property along Bayou St. John in 1857, reminiscent of those from the previous century. *Picou, Jules. Plan Book 24, folio 22, (024.022), July 24, 1857. Courtesy of Dale N. Atkins, Clerk of Civil District Court, Parish of Orleans.*

Below: The Folly Plantation along Bayou St. John, mid-1800s. *Folly Plantation along Bayou St. John Unsigned. Plan Book 105, folio 43, (105.043), Undated. Courtesy of Dale N. Atkins, Clerk of Civil District Court, Parish of Orleans.*

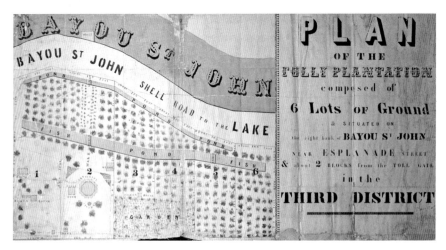

the Port of Bayou St. John, was where shallow-draught vessels suitable for navigating the bayou's modest depth could dock and unload supplies. Eventually, the supplies would be transferred onto carts before making the trek across the winding portage into town.[78]

By the 1720s, the portage, now called Bayou Road (*Le Chemin au Bayou St. Jean*), had become a farming village of sorts. The road from the bayou led to a point around the present-day intersection of Bayou Road, Dorgenois, Bell and DeSoto Streets, with one path following along Bayou Gentilly (along present-day Gentilly Avenue) and the other continuing on toward the Vieux Carré along what is roughly the present-day path of Bayou Road. The corridor was of such importance to the early city that land grants, both French and later Spanish, were oriented along its axis. Esplanade Avenue was extended to the bayou in the middle of the nineteenth century, influencing the area's subsequent street grid, but according to architectural histories of the area, "One still finds an occasional house and property line with an ancient alignment, reflecting the early history of this section."[79]

The colony's economy, particularly early on, did not enjoy clear divisions of labor, despite colonial officials' best efforts. White settlers, slaves and Native Americans all participated actively in what Usner terms Louisiana's "frontier exchange economy." The Company of the Indies wanted skilled labor as cheaply as possible, and according to Usner, "As early as 1716 General Commissioner Hubert had recommended that Native American and Negro slaves could 'be used very advantageously to learn the different trades of the workmen…in order that they may serve to replace them.'"[80] The variety of occupations permitted these groups allowed for relative fluidity within the town's early economic system. Add to this formula the area's network of Native American marketplaces that resulted from its dependence on local tribes for food, the market traditions Africans brought with them and planters' frequent inability to feed their slaves, which led to slaves growing and selling their own food, and you get a thriving frontier trade economy that involves all of the city's early inhabitants.[81]

One particular Native American market in the early city exemplified the exchange of goods occurring between colonial residents and the area's indigenous communities at the time. The Chaouacha, Bayogoula, Houma, Acolapissa, Chitimacha and Tunica tribes surrounded the city when it was founded in 1718, in a radius of roughly one hundred miles, supplying meat, corn, beans and other goods to its struggling settlers. According to historian Jerah Johnson:

Left: A property facing Bayou Road, shown in relation to the orthogonal street grid later determined by Esplanade Avenue. *Castaing, Alexander. Plan Book 44, folio 69, (044.069), February 12, 1862. Courtesy of Dale N. Atkins, Clerk of Civil District Court, Parish of Orleans.*

Below: An 1817 map of the present-day French Quarter with Bayou Road heading off toward Bayou St. John. *Library of Congress.*

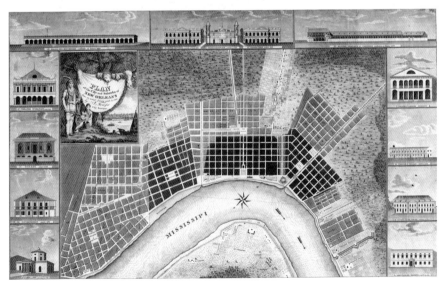

New Orleans' earliest, as well as its last, all-Indian market was held in an open area…at the conjunction of what are now Esplanade Avenue, Bayou Road, Dorgenois, Bell, and DeSoto streets. It lasted, with gradually dwindling numbers of Indians after 1809 (when the opening of Faubourg St. John separated it from Bayou St. John, which had been the main route the Indians followed into town), until the construction on that spot of the LeBreton Market building in 1867.[82]

Given the formation of the original portage trails in this location—where the path along Bayou Gentilly and the one leading from Bayou St. John merged before heading off toward the riverbank—this location for a major Native American market makes perfect sense. The spot marks the coming together of two important trade corridors, as marked by their respective bayous: an ancient intersection long before it was a modern one.[83] Future landowner Daniel Clark Jr. would choose this very site for his "country seat," which was also intended to be the central focal point for his proposed neighborhood, Faubourg St. John (the street grid featured here), in the early years of the following century.[84]

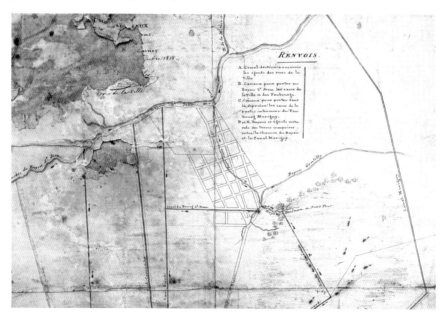

Map of Bayou St. John, Bayou Gentilly and the little stream of various names (with portage alongside) that connected them. The fan-like formation of streets at the end of Bayou Road marks the spot where the city's earliest Native American market was, 1818. *Map Collection, ms5, Louisiana Division, New Orleans Public Library.*

Left: A property along Bayou Road across the street from the market, 1852. *Giroux, Claude and Alexander Castaing. Plan Book 48, folio 22, (048.022), February 4, 1852. Courtesy of Dale N. Atkins, Clerk of Civil District Court, Parish of Orleans.*

Right: An 1804 map showing the connection between Bayou St. John and Bayou Gentilly. *Library of Congress.*

Almost immediately following the founding of New Orleans, plans were made to cut a canal from the river to the lake using Bayou St. John. Not only would this serve as an aquatic avenue for the transportation of goods and supplies (as opposed to Bayou Road's clumsy overland passage), but it would also mitigate flooding by acting as a drainage outlet. Governor Étienne Boucher de Périer reported to the Company of the Indies in 1727 that he planned to dig a canal from the city to the bayou. In 1733, once Bienville was reinstated as governor, he set his sights on a canal from the city to the bayou by conceding a hunk of land to the Jesuits on the condition they facilitate its dredging. Yet each time, the canal never materialized. It would be another seventy years before Governor Francisco Luis Hector, barón de Carondelet, with the help of dozens of convicts and slaves, succeeded in making it a reality.[85]

Regardless of the status of this canal extension, improving the condition of the bayou itself to facilitate commerce was both a priority from the

colony's earliest years and a theme that would echo throughout the centuries to come. In 1725, Bienville wrote to the Company of the Indies requesting equipment to this end:

> *Bayou St. Jean, which is behind the city, is of such great convenience because of the communication which it affords with Lake Pontchartrain, and consequently with the sea, that it cannot be esteemed too highly. In order to facilitate navigation, what would be necessary to clear it out, is to remove from it all the trees that hang over its banks and threaten to fall into it. A good settler on this bayou named Rivart* [Rivard]*…offers to undertake this work…For that purpose he asks that we lend him the pulleys, tools and ropes necessary…*[86]

Two hundred years later, when the bayou's usefulness to the city was being hotly debated after its commercial relevance had long since peaked, pleas for the city to improve its unsightly and inefficient aspects took on a strikingly similar tone. *Plus ça change*, as we will see in chapter 4.

Although recreation along the bayou's banks blossomed in earnest during the nineteenth century, a recently discovered memoir, written by a young clerk for the Company of the Indies who lived in the city from 1729 to 1731, gives us an exquisite taste of Bayou St. John's recreational happenings during the French period. Bookended by descriptions of the gruesome 1729 Natchez Native American revolt upriver and subsequent French retaliation, twenty-two-year-old Marc-Antoine Caillot tells of the first documented Carnival celebration in New Orleans—which took place on the banks of Bayou St. John. On Lundi Gras 1730, Caillot describes going in to the Company office where he was employed and proposing some Carnival fun to his co-workers: "I proposed to them that we form a party of maskers and go to Bayou Saint John, where I knew that a lady friend of my friends was marrying off one of her daughters."[87] François Antoine Rivard, the son of 1708 settler Antoine Rivard, and his fifteen-year-old stepsister, Jeanne Antoinette Mirebaize de Villemont, were getting married at the home of Antoine Rivard's recent widow, Antoinette Fourier de Villemont Rivard. Later that night, Caillot gathered up some friends and they all dressed up in women's clothes (a Carnival tradition not uncommon in Paris at the time). They stumbled upon a violinist and an oboe player, and the whole bunch set off into the night with a few slaves carrying flambeaux to light their way.[88]

The costumed group trudged along Bayou Road—which, earlier in his account, Caillot had noted was home to a "very nice brickyard…and

an earthenware factory."[89] A decade or so later, by the 1740s, Freiberg tells us Bayou Road was punctuated with the "wide, red-roofed, severely plain dwellings of the rich," nestled among hardwood trees and backed by cultivated fields.[90] Caillot and his crew must have passed some of these houses—raised on pillars, belted with verandas. He described going about the distance of "two musket shots" when the party came across "four bears of frightful size," which they luckily frightened off with the flambeaux.[91] The party finally reached the bayou, which Caillot describes earlier in his account as having had "three boats and one longboat" and boasting "five or six inhabitants very rich in livestock."[92] They partied well into the night, and our Caillot fell madly in love with a young Mademoiselle Carrière. Caillot describes finally having to head back "since it was close to four o'clock in the morning."[93] They returned the next day and repeated the fun all over again. Although Caillot's romance with Mademoiselle Carrière was apparently fleeting, this snapshot of one of the bayou's earliest celebrations will certainly live on.

In 1766, another visitor to the city—Captain Harry Gordon, chief engineer in the Western Department in North America, who was sent from Pittsburgh to New Orleans via the Ohio and Mississippi Rivers—provided us with yet another snapshot of the bayou around the time the city was transferred from French to Spanish control. Captain Gordon wrote in his journal:

> We left New Orleans the 15th in the Evening, and lay that night at the Bayoue. To this Place the Trade from Mobile comes, and all manner of Smugling: There are Three Schooners, constantly ply[ing] between the East Side of Lake Pontchartrain, and here, Employed in bringing Tar. There is a good Harbour for Craft here....The 16th in the Afternoon We went along the Bayoue, which is 2 Leagues long, and only Twenty Five Feet wide in many Places; It is deep enough but the Windings are so Short sometimes, that a Schooner has Difficulty to turn; The Grounds on Each side were under Water Except in three or four Places where Rice had been cut off, and in general the Country is Overflowed, between Lake Pontchartrain and the Mississippi, to within 2 Miles of the last....At Dusk we passed the Blockhouse [fort] at the Opening into Lake Pontchartrain, in which was a Serjeant and 12 Men, French and Spaniards, and some small Cannon Mounted; We continued Rowing till 11 o'clock and rested. Next Day by Noon we were across the Lake, the Wind in our Teeth.[94]

Spanish Rule

In 1762, following the Treaty of Fontainebleau, New Orleans transferred into Spanish hands. The town experienced an economic boom in the four decades to follow, and the plantation economy of the city's outskirts finally came into its own. While slave imports from Africa had slowed considerably after the 1730s, they surged after Spain took over, peaking in the 1780s. Meanwhile, Spain's liberal manumission policy (which allowed slaves to purchase their freedom or be freed by their owners), as well as planters' fears in response to the Saint-Domingue slave uprising of the 1790s (which meant a temporary curtailment in slave imports paired with more repressive slave laws), meant that slavery in New Orleans during the second half of the eighteenth century was even more complex and erratic than it was during the French period.[95]

The Bayou St. John–Bayou Road corridor felt these changes at every turn. For one thing, free people of color began buying land along Bayou Road, beginning a trend that would continue well into the next century. But it was the ever-encroaching backswamp that witnessed slavery's repercussions most directly. *Marronnage*, or the act of slaves escaping, hit its stride during the Spanish period. The *ciprière*, or cypress forest, comprising the tail-end of every ribbon-shaped plantation fronting the town's waterways, was a space where slaves were frequently required to work. And yet few masters were willing or able to follow them into the swamp if they were to stray beyond the property line. According to historian Gwendolyn Midlo Hall, "Each plantation had its trackless *ciprière*, where slaves from various estates met, worked together, learned how to survive on their own, and eventually escaped in large numbers."[96] The proximity of the swamps meant maroons, or escaped slaves, often did not seek total separation from the city but sought ways to hide in its watery periphery while still benefiting from its economy.[97]

Although some maroons continued to pillage from plantations and kill cattle—a common complaint among planters during the French period—many maroon communities during the Spanish period moved more toward production and trade for survival. They sold cypress to sawmill operators who stood to benefit financially from the exchange and so did not report them. According to Hall, they also fished, wove baskets, trapped birds, foraged for food and grew crops.[98] A verse from a Creole slave song paints a picture of maroons' way of life along the area's waterways, including, presumably, the undeveloped stretch of swamp along Bayou St. John's middle section: "Little ones without father,

FIFTY DOLLARS REWARD—Will be paid to any person who will lodge in either of the city jai's, or at No. 14 Toulouse street, First Municipality, the slave LUCINDA. She is about 5 feet 5 inches high; is of good figure and voluptuous shape, and by her neat manners might be taken for a hair dresser; her complexion is rather fresh and florid; has fine teeth, regular features and slender neck; she speaks French and English, generally the latter. She was seen three months ago near the Pontchartrain Railroad in company with a mulatto boy; she has also been seen with a fishing party at Bayou St John and at the Lake. She has been away since October last. my10—3t*

Runaway slave advertisement from May 13, 1851, in which Lucinda was last seen with a fishing party near Bayou St. John. *From the* Times-Picayune *(formerly* Daily Picayune*), 1937–present, Louisiana Division, New Orleans Public Library.*

little ones without mother, / What do you do to earn money? / The river we cross for wild berries to search; / We follow the bayou a'fishing for perch / and that's how we earn money."[99] Powell mentions groups of slaves seen walking up and down the bayou at the end of the eighteenth century, claiming to be fishermen.[100] *Marronnage* to the city's swampy outskirts would continue largely unabated throughout the antebellum period, much to slave owners' distress; the landscape, in its very wildness, offered refuge to those hoping to escape the civilizing forces of the city.

In the 1770s, the bayou's banks also saw the manifestation of new relationships between white men and free women of color. These intimacies were common enough in North American slave societies but were particularly prevalent in Spanish New Orleans. They occasionally resulted in economic advantages for women of color, if not manumission, and/or patrimony and economic advantages for their offspring. In 1774, Andres Jung, a prominent bayou resident, sold a piece of land in the vicinity of present-day lower City Park to Mariana, a free woman of color—which may signify the first time any property along the bayou was owned by a person of color. He sold her the property for the same price he paid for it, retaining the rights to cut cypress trees on the land. Jung was said to have had three children living in his home, all products of sexual relations with his slaves, to whom he allocated money upon his death.[101]

Properties along the bayou's southern stretches were not the only ones changing hands during these years. In 1765–66, after New Orleans had come under Spanish control but had yet to receive its first Spanish governor,

previously undeveloped property along the bayou between Metairie Ridge and the lake began to get snapped up, no doubt due to prominent citizens' insecurities stemming from the exchange of power. Up until this time, activity on the bayou had been primarily limited to its mouth and the Port of Bayou St. John; between these two points, the bayou's *ciprière* had been largely unoccupied. Charles-Philippe Aubry, interim French governor, facilitated property purchases all along the bayou's length. Up until 150 years later, the legality of these interactions was still being challenged when courts questioned whether Aubry, a French representative, had had the right to grant land owned by the Spanish.[102] Freiberg surmises that the real estate boom in the 1760s, combined with the small community that had grown up around the bayou's mouth, began a kind of hum of energy around the bayou's intersection with Lake Pontchartrain—perhaps precursor to the site's century-long tenure as a resort destination beginning in the 1820s.[103]

It was during the 1770s and 1780s that a few highly influential residents, members of the increasingly powerful Creole governing class, began acquiring property on the bayou. Shrewd businessman Gilbert Antoine de St. Maxent, who benefited from his allegiance to the new Spanish governor Antonio de Ulloa, acquired in 1772 one piece of property on the east bank of the bayou and another on the Gentilly High Road, among many others. His bayou holding stretched from around the present-day Wisner Overpass to the middle of present-day Park Island.[104] By the 1770s, thanks in large part to his monopoly on the Missouri River fur trade, he was thought to be the wealthiest man in the colony.[105] The city's first major philanthropist, who by the mid-1780s had become the city's richest resident, surpassing even St. Maxent, owned property on the bayou as well. Andrew Almonester y Roxas's many philanthropic contributions to the city included rebuilding Charity Hospital after the back-to-back hurricanes of 1779 and 1780 and the construction of a lepers' hospital on the edge of his plantation around the present-day intersection of North Galvez Street and Bayou Road.[106]

In the last decade of the eighteenth century, before New Orleans changed hands yet again, Governor Francisco Luis Hector, barón de Carondelet, would spearhead one of the biggest public works projects to date. Concerned the city would soon be uninhabitable without some sort of major drainage solution, and with the added argument that the Crown would save money in overland shipping costs associated with Bayou Road, he ordered a canal dug from the bayou to the rear of the city with slave labor "donated" by the city's wealthy inhabitants in 1794. The canal, which would prove an important commercial conduit for the next century, would stretch a mile and

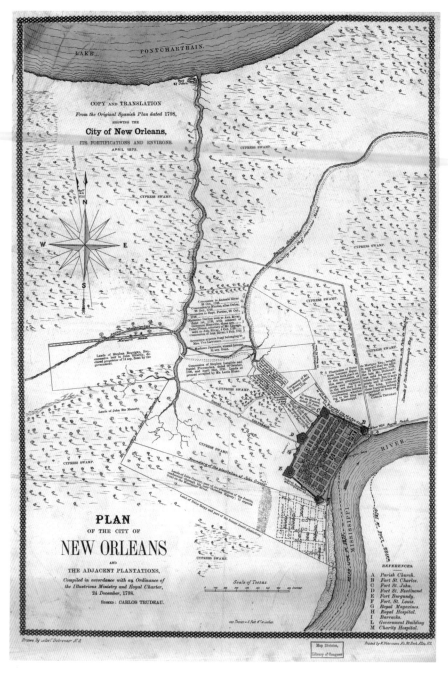

Map showing the Carondelet (Old Basin) Canal connecting Bayou St. John to the edge of the French Quarter, 1875. *Library of Congress.*

a half from the main channel of the bayou to a turning basin at the rear of the French Quarter (at present-day Basin Street, near the corner of North Rampart Street and St. Peter Street) along the approximate strip occupied by today's Lafitte Greenway.[107]

Carondelet's plan was for a thirty-foot-wide by four-foot-deep waterway, with sixty feet on either side for promenades. The creation of the Carondelet (Old Basin) Canal involved cutting through ten thousand feet of dense forest in the heat of the summer. The first attempt resulted only in a glorified ditch, six feet wide and about three feet deep. Within a couple years, the canal was widened to fifteen feet and a wooden embankment was added to either side, although it remained shallow. Some sources suggest that funds derived from this canal created the city's first police force. Local plantation owners, beyond lending their slaves out to dredge the canal, also had to pay the city for the right to use it to drain their plantations, and the proceeds were used to pay a series of wandering patrolmen charged with keeping the peace.[108] After the end of Carondelet's tenure as governor, alas, the canal fell into disrepair. Decisions over improvements to the canal and the bayou itself, and who should pay for them, would come to be one of the defining narratives of the augmented waterway. As we will see in chapter 4, issues surrounding use and control of Bayou St. John that begun in earnest with the digging of the Old Basin Canal continue to this day.[109]

If you could again travel back to the bayou at the end of New Orleans' colonial period, to the same spot you'd visited before—where present-day Esplanade Avenue meets present-day Moss Street—you'd witness the hustle and bustle of water-based commerce flanked by small-scale plantation agriculture. Perhaps you'd see a schooner, three-sailed and flat-bottomed, moored off the bank nearby, awaiting higher water to make its escape through the bayou's shallow mouth into Lake Pontchartrain. Perhaps a flatboat loaded with timber or lime or livestock would pass by on its way to the bayou's intersection with Bayou Road—since the Old Basin, at this point, would have been too clogged with mud for anything larger than a pirogue. Perhaps, down the bayou a ways, a man would raise a wooden drawbridge to allow a flatboat through. Along both banks, to your left and right, several houses would sit—galleried, plastered with crushed shells from Lake Pontchartrain, surrounded by fruit trees and slave cabins and storerooms and crop-lined fields. You might see the hulk of a farm implement silhouetted against the sky or cows grazing in the distance. If you could again climb a tree—perhaps a southern magnolia on the edge of the plantation behind you—and look toward the river, you would see a

potholed Bayou Road, busy with mule-drawn carts. More orange groves and gardens stretching like wings along Bayou Road's spine. More fields and country seats. The next time you'll stand here, at the end of the next century, a thoroughfare called Esplanade Avenue will have been sliced through the fields behind you, delivering travelers from the French Quarter riverfront to a bayou no longer defined by rural aristocracy but by industry and residential expansion.

INDUSTRY AND PLEASURE GARDENS

1804–1900

While waterways were integral to trade and transportation during the colonial era, the advent of railroads and competition from the New Basin Canal in the 1830s changed the bayou's role within a rapidly changing city. In the decades to follow, as the bayou's commercial relevance gradually declined, its recreational relevance was recognized for the first time in the form of rowing races and luxurious pleasure gardens. An even bigger change was on the horizon: advances in drainage, concurrent with shifts in values surrounding public spaces associated with the City Beautiful movement, marked a major shift in the bayou's history at the turn of the twentieth century. But at the turn of the nineteenth century, the bayou was still primarily used for commerce and conveyance—while the city, once again, prepared itself for an exchange of power.

Bayou St. John, Officially American

In the 1790s, as the city's slaves were gouging Carondelet's trench across the swamp, a major uprising in France's sugar island of Saint-Domingue (present-day Haiti) was gaining strength. In 1800, New Orleans was secretly transferred from the Spanish back to the French following the Third Treaty

of San Ildefonso. Soon after, Saint-Domingue's slave rebellion prompted Napoleon, far less interested to begin with in the expensive and ungainly Louisiana colony than his profitable island to the south, to sell off the entire Louisiana territory to the United States. In this transaction, the Louisiana Purchase, the United States acquired a vast swath of land stretching from the Mississippi's mouth to present-day Canada. On December 20, 1803, New Orleans' colonial era slammed shut.[110]

When Louisiana officially entered the Union several years later in 1812, an important federal policy endowed the bayou with an essential status. Prior to the American Revolution, navigable waterways in the thirteen colonies were owned by the English Crown; after 1776, when American citizens became sovereign, navigable waterways were then transferred to the states for public use.[111] As lawyer William C. Hollier describes it:

> *The title to the beds of navigable bodies of water has traditionally been regarded as being vested in the state* [of Louisiana] *since its admission to the Union in 1812. This view finds support in the Civil Code, which distinguishes between common, public, and private things. Article 450 defines common things as those belonging to no one in particular, such as "air, running water, the sea and its shores." Public things are distinguished from common things in Article 453 as property belonging to the "whole nation" for the use and benefit of all its members. Article 482 makes it clear that these things were not intended to be susceptible of private ownership.*[112]

If a waterway was navigable in 1812, meaning used as a highway for commerce in its natural state, then it would still be considered navigable today. Although the implications of this legal designation are constantly being settled and resettled on a national level, the status itself remains central to issues surrounding ownership and use—for any navigable waterway and for Bayou St. John. There is no essential difference, at a legal level, between the questions that might arise around use and control of the Mighty Mississippi and those that might arise around use and control of Bayou St. John. It wasn't until the turn of the next century that these issues first came to a head for the bayou, but its essential status as a navigable waterway was granted on April 30, 1812.[113]

In the years following the Louisiana Purchase, New Orleans as a whole underwent a demographic revolution. Over the course of the previous decades, English-speaking Anglo-Americans like future Faubourg St. John developer Daniel Clark Jr. had found opportunity in New Orleans,

capitalizing on the river's commercial power.[114] After the Louisiana Purchase, the city experienced an even more massive migration of these Anglophones. Their arrival triggered a decades-long period of tension between the Americans and those who identified as "Creole." Forced into clarity by the arrival of "outsiders," the ever-fluid term *Creole* would come to essentially mean "native-born" in the early 1800s: in general, those primarily Catholic descendants of the French, Spanish and African people who had first populated the colony.[115] The influx of Anglophones, with the Creole population meanwhile seeking allies in Saint-Domingue refugees and the "foreign French" arriving concurrently from Europe, catalyzed new ways of intermingling in the fast-growing city.

Jacques-Francois Pitot, a Saint-Domingue refugee whose name is associated with the bayou of today, came to New Orleans in 1796 by way of Philadelphia. Perhaps inspired by his inelegant arrival—the bayou's silt-choked mouth blocked his schooner from entering from Lake Pontchartrain—Pitot founded the Orleans Navigation Company in 1805. The company intended to improve navigability on the bayou and its manmade leg and, in the following decades, facilitated the construction of dikes at the bayou's intersection with the lake and the removal of obstructions along its length. Legal disputes surrounding tolls and landownership plagued the company's tenure, however, prompting the waterway's transfer to a new company, the Carondelet Canal and Navigation Company, in 1857. Nonetheless, an 1820s observer wrote the following testament to the Orleans Navigation Company's achievements up until that point:

> *Where there was formerly a filthy ditch and noisy frog-pond, we find a beautiful canal, with a good road and walks on each side, with gutters to drain off the water, and a large and secure Basin where vessels can lie in perfect safety at all seasons.*[116]

By 1810, Jacques (James) Pitot had purchased a house on the bayou. The house, now referred to as "The Pitot House," was restored and relocated in the 1960s and now serves as a museum and the headquarters of the Louisiana Landmarks Society. Pitot went on to become a prominent judge and merchant, as well as the first elected mayor of the new American city in 1804–5.[117]

By the 1830s, New Orleans had become one of the busiest port cities on the globe, thanks in large part to the influx of American economic practices. And yet, while the Americans enjoyed growing commercial dominance, they found

it far more difficult to gain control in a political landscape still dominated by Creoles. In response to political gridlock, a solution was proposed entirely unique among American cities: to split New Orleans into three semiautonomous cities, divided loosely along the boundary lines that separated American and Creole populations. The Americans gained legislative permission to force the split in 1836. The First and Third Municipalities (which included Bayou Road and Bayou St. John) were constituted primarily of Creoles, including free people of color and foreign French. The Second Municipality, upriver from the French Quarter, was constituted primarily of Anglo Americans. Each municipality had its own council and municipal court system and conducted business in its own official language.[118]

Unsurprisingly, the arrangement proved inefficient, and it dissolved in 1852. But by then, the Americans had allied with another set of newcomers—German and Irish immigrants—ultimately outnumbering the Creoles. As American culture began to take hold, tensions that once surrounded issues of nativity would now center on issues of race, according to the black-and-white racial binary system embraced by the rest of Anglo America. This would have dire consequences for the city's native and free people of color populations, occurring in tandem with the economic revolution the Americans set in motion.[119] According to Campanella:

> The turn of the nineteenth century thus saw New Orleans transform from an isolated colony engaged in a regional-scale frontier exchange economy, to a key cog of a vast, export-driven Atlantic World economy. Out went colonial Louisiana's low-value, hither-and-thither exports, catalogued in 1791 as "indigo…skins of wild beasts, timber, lumber, planks, shingles, rice, tobacco, and corn…"; in their place came vast, monocultural, slave-labor plantations of cotton and sugar, the former above Baton Rouge, the latter throughout the Louisiana deltaic plain southward to the sea.[120]

Even while New Orleans was expanding, both in terms of population and in terms of wealth, in some ways, it was not expanding at all: at the time of the Louisiana Purchase, most of the city consisted of a compact grid along the river, a mere eleven by six blocks. Development spilled along the ridges that scarred the swamp behind it—as evidenced by the small plantation communities along Bayou Road and Bayou St. John—but these settlements remained sparse.[121] The more the city grew, the more this "untamable" swamp behind the city began to take on symbolic significance beyond even its logistical implications. As a writer for the *Daily Picayune* exclaimed in

1854, New Orleans would forever remain "a long, narrow belt of a place, straggling up the river"[122] if it could not find a way to expand into the as-yet-uninhabitable "back of town" (defined, at that time, as extending toward Lake Pontchartrain from around North Rampart Street).[123]

And yet in some areas of the city, expansion that should have been possible for topographical reasons remained impossible for legal ones. In the years immediately following the Louisiana Purchase, Daniel Clark Jr. (by now one of the richest men in North America) set out to develop his own neighborhood, or *faubourg*, along the slopes of present-day Esplanade Ridge. After moving to New Orleans following the American Revolution, he began buying up plantations in the area of what is now considered the Fairgrounds and Faubourg St. John neighborhoods. He envisioned the streets of his future faubourg radiating outward from his country manor, Place Bretonne, like the spokes of a wheel.

In theory, Faubourg St. John's development should have been successful: it was on high enough ground, and although it wasn't directly adjacent to the city's urban center, it was accessible via Bayou Road and the Old Basin Canal. And yet the neighborhood did not materialize for the better part of a century, due to Daniel Clark's daughter, Myra Clark Gaines, and her lengthy battle to claim her father's vast fortune. Twenty-one years after her father's death in 1811, Clark Gaines, the product of her father's affair with a young Louisiana-born Frenchwoman, filed what would become one of the longest-running lawsuits in U.S. history in order to prove her legitimacy as sole and rightful heir to, among other assets, Clark's land holdings. Much of the land that makes up today's Faubourg St. John was tied up in the epic court battle and therefore sat in development limbo for the duration of the lawsuit's fifty-seven-year lifespan.[124]

Meanwhile, other faubourgs cropped up. Those below the French Quarter and along Bayou Road offered residence to primarily Creole families, including free people of color.[125] Esplanade Avenue, planned in the manner of a French "garden suburb" for wealthy Creoles looking to escape the Quarter, was extended to the bayou in the 1830s.[126] In future years, this "streetcar suburb," so called for the new amenity it sported, continued to attract wealthy residents throughout the nineteenth century and, in the twentieth century, would be joined by Lakeview and Gentilly—neighborhoods advertised as accessible yet sufficiently separate from the hassles of urban life.[127] Despite the orthogonal influence of this tree-lined thoroughfare, Bayou Road remained an important enough corridor to maintain its meandering footprint at the time of Esplanade Avenue's extension to City Park.

Right: Portrait of Myra Clark Gaines, circa 1855–65. *Library of Congress.*

Below: Esplanade Avenue, from the French Quarter looking toward Bayou St. John. *From Louisiana Postcard Collection, Louisiana Division, New Orleans Public Library.*

Affluent citizens continued to build homes along Bayou Road's diagonal reach, like prominent Greek merchant Nicolas Marino Benachi: his stately home (1858–59) now hosts parties and weddings at 2257 Bayou Road, between North Rocheblave and North Tonti Streets.[128]

RECREATIONAL RENAISSANCE

Although a comprehensive drainage solution for the city's swampy sections remained out of reach until the end of the century, canals and railroads inspired new uses for the "back of town" spaces that stayed dry enough to warrant such development. Landscape architect Lake Douglas maintains that as the first aquatic thoroughfare of its kind, the Old Basin Canal/Bayou St. John corridor "was one of the earliest locations in the nineteenth-century community where residents could experience public and private outdoor spaces created for recreational and leisure activities, unrelated to residential uses and military or ceremonial activities."[129]

Perhaps the most well known of these recreational spaces was the Spanish Fort summer resort. Beginning in the 1820s, it bloomed at the bayou's intersection with Lake Pontchartrain atop the foundations of the colonial fort originally built there by the French. An 1841 *Times-Picayune* advertisement describes the resort hotel and its offerings: "The fine Hotel at the Lake end of the Bayou St. John is now ready for the reception of visitors, having every variety for amusement—Billiards, pistol shooting, bathing, &c. The Restaurant is furnished with the best the markets afford."[130] The Bayou St. John Hotel attracted wealthy city-dwellers like society woman Eliza Ripley, who wrote about her excursions to the hotel in the 1840s in her *Social Life in Old New Orleans*:

> *There was a large hotel (there may be still—it is sixty years since I saw it), mostly consisting of spacious verandas, up and down and all around, at the lake end of the shell road, where parties could have a fish dinner and enjoy the salt breezes, but a dinner at "Lake End" was an occasion, not a climax to a shopping trip. The old shell road was a long drive, Bayou St. John on one side, swamps on the other, green with rushes and palmetto, clothed with gay flowers of the swamp flag. The road terminated at Lake Pontchartrain, and there the restful piazza and well-served dinner refreshed the inner woman.*[131]

Beginning in the 1870s, other features were added to the site, like promenades along the bayou and among the fort's ruins, a casino, a theater, amusement park rides, dancing pavilions and restaurants, all accessible by railroad. Some sources maintain that Spanish Fort, along with its younger siblings Milneburg and West End, were sites where early New Orleans jazz was developed.[132] In his 1883 *Life on the Mississippi*, Mark Twain describes the mini resort towns along the lakeshore: "Thousands of people come by rail and carriage to West End and to Spanish Fort every evening, and dine, and listen to the bands, take strolls in the open air under the electric lights, go sailing on the lake, and entertain themselves in various and sundry other ways."[133]

BAYOU ST. JOHN HOTEL.
The subscriber respectfully informs his friends and the public generally, that he has taken the Hotel at the Lake end of the old Shell Road, better known as "the old Fort House," where he will be found ready at all hours to furnish persons visiting the Lake for health or pleasure, with fish, crabs, or any other dainty the season may afford, in good style and on the shortest notice.

The bar is bountifully supplied with the choicest wines and liquors; and his charges to persons visiting him will be moderate.

je4 2in* **S. MAYER.**

Left: Bayou St. John Hotel advertisement from September 17, 1843. *From the* Times-Picayune *(formerly* Daily Picayune*), 1937– present, Louisiana Division, New Orleans Public Library.*

Below: Bayou St. John Light, before 1878. *National Archives.*

Night scene at Spanish Fort. *From author's postcard collection.*

Across from Spanish Fort, the first lighthouse built outside of the original thirteen U.S. colonies stood guard on the bayou's banks. Established in 1811, sources estimate that the Bayou St. John Light was in operation—with brief lapses in service due to fire and hurricane damage—for somewhere between sixty-five and one hundred years. In the early 1900s, several sources report that the widow of the former lighthouse keeper, Robert Gage, took over as keeper. Mrs. Annie Gage was soon succeeded by her daughter, Mrs. M.E. Coteron. Lighthouse keeper was one of the first nonclerical government jobs available to women, and Mrs. Gage and her daughter joined the ranks of the roughly 170 female lighthouse keepers who served from the mid-nineteenth century to the early years of the twentieth century across the United States.[134] The Bayou St. John lighthouse, although humble, was a pioneer in more ways than one.[135]

Meanwhile, the bayou's southernmost portion, where its waters straddled Metairie Ridge, had attracted city-dwellers since the founding of New Orleans. In the mid-nineteenth century, this relationship between the densely packed urban center and the bayou's recreational potential crystallized. Beginning after the Civil War, city residents would dress up and trek out by the hundreds to watch races put on by "crews" like the renowned St. John Rowing Club. This *Times-Picayune* article from 1875 paints the scene:

Everybody goes to the St. John [rowing club] *anniversaries. From my lady's satin lined barouche to the resurrected baker's cart full of ragged children, all grades and classes of wheeled vehicles are there. And pedestrians and voyagers by the humble street car throng the edges of the water in masses, so dense and solid that it is a constant wonder how the horses and carriages ever penetrate them....We fancy it would be hard to light upon a prettier or more animated scene than was presented by the banks of Bayou St. John last evening, with the flutter of lace, the sheen of silk, and the bright coloring of spring fabrics that fringed them like a soft illuminated border. The voices, the sounds of merriment and the sweet laughter of woman completed the tableau—as radiant and gracious an ensemble as one would care to look upon.*[136]

Aside from rowing races, "pleasure gardens"—private commercial entities with recreational offerings—also blossomed along the bayou and the Old Basin Canal beginning in the 1800s.[137] Irish traveler Thomas Ashe describes a Sunday scene at the bayou's "Tivoli" pleasure garden in 1806:

[A]*ll the beauty of the country concentrates, without any regard to birth, wealth, or colour....The room is spacious and circular; well painted and adorned, and surrounded by orange trees and aromatic shrubs, which diffuse through it a delightful odor. I went to Tivoli, and danced in a very brilliant assembly of ladies.*[138]

Along the bayou and the canal, The Tivoli (circa 1805), Jardin de Rocher de Ste. Helene (1840s), Tivoli Gardens (1840s–66), Vauxhall Gardens (1850s) and Magnolia Gardens (circa 1866), lush with ornamental greenery, provided customers with music, ballrooms and barrooms, dance halls, games and refreshments of all kinds.[139] Congo Square, adjacent to the Old Basin Canal's turning basin at the edge of the Vieux Carré, served as a gathering place for slaves and free people of color over the course of the nineteenth century and has remained a significant cultural landmark ever since, retaining a presence in the city today within Louis Armstrong Park.[140]

In those years, the turning basin thrummed with commerce, even as the canal itself, only three and a half to six and a half feet in depth, had to be dredged seemingly constantly to allow even flat-bottomed craft to ply its length. In the basin, scows, schooners, luggers and sloops sat in clusters while workers loaded and unloaded timber, oysters, charcoal and other

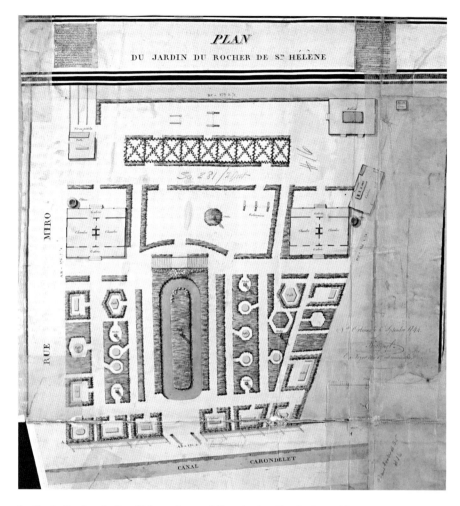

Jardin de Rocher de Ste. Helene. *Bourgerol, Jean Antoine. Plan Book 35, folio 16, (035.016), September 4, 1844. Courtesy of Dale N. Atkins, Clerk of Civil District Court, Parish of Orleans.*

goods. Oyster houses on North Rampart Street awaited shipments of the bivalves. Planing mills and lumber yards along the edge of the canal, like Jouet Lumber Yard on Toulouse Street, processed timber shipped to the city from points north of the lake.[141]

But despite its traffic, Bayou St. John and the Old Basin Canal could not adequately support the increasing trade between New Orleans and its outlying partners in the Florida parishes and other Gulf coast cities.[142] So in 1831, downtown investors sliced a railroad through the swamp between the Faubourg Marigny and the lake, tracing the path of present-day Elysian

Left: Advertisement for E. Hacker, dealer located in the Tremé Market along the Old Basin Canal. *Gardner's New Orleans Directory 1866, Louisiana Division, New Orleans Public Library.*

Below: Homes and businesses near the turning basin of the Old Basin Canal, 1883. *Robinson's Atlas of the City of New Orleans, Louisiana, 1883, Plate 7. Courtesy of Dale N. Atkins, Clerk of Civil District Court, Parish of Orleans.*

Fields Avenue. In 1832, an uptown answer followed: predominantly Irish laborers, suffering under horrendous work conditions, dredged a sixty-foot-wide, vaguely L-shaped canal from the present-day intersection of Loyola Avenue and Julia Street toward the lake.[143] Slaves were considered too expensive to risk when it came to this back-breaking work, particularly given the threat of yellow fever. Meanwhile, inexpensive immigrant labor was all too available, particularly given the wave of Irish immigrants to the city between the 1830s and 1850s.[144] The New Basin Canal—not to be confused with the Old Basin—was completed in 1838. Both new corridors boasted their own lakefront resorts before long: Milneburg, at the end of what is now Elysian Fields Avenue, and West End, where the New Basin Canal flowed into Lake Pontchartrain.[145] The bayou had new competition in more ways than one.

THE BAYOU IN THE CIVIL WAR

Of course, no history of the nineteenth century in America is complete without mention of its most famous event, and indeed, the bayou played a role—albeit a modest one—in the city's engagement in the Civil War. Twenty-seven-year-old Gilbert Shaw of the Forty-Second Massachusetts Volunteers wrote letters to his parents about his experience stationed on Bayou St. John during the Union occupation of New Orleans. Although his time in New Orleans was relatively uneventful, his letters provide us with an often amusing window into what his days were like living along the waterway.

In a letter dated April 25, 1863, he wrote, "The other Night a gun was fired out on the Bayou & you had ought to see how quick some of the Boys turned out ready for a fight. We get so we don't mind much about such things." In another letter, dated May 14, Shaw described a humorous accident concerning a delivery of rations to their camp: "When they were coming up with them they got the <u>Mule</u> and <u>Cart</u> into the Bayou. They got everything out but the Beans. Them we left—soaking for the next time we come out <u>for the War of 1890.</u>" In yet another epistle from a few days earlier, he wrote about "registered enemies," or civilians resisting Union occupation, "leaving the city as fast as they can" through the bayou and across Lake Pontchartrain:

> *Some of the women hated to leave the worst kind.... One young girl went over with her Folks and left a brother here. He was about twenty years old.*

She cried all the time the boat was stopped & when it started it seemed as though she would give up. I tell you what it is. This going off and leaving Friends is hard. I think I know something about that myself.[146]

Some sources suggest that a Confederate shipbuilding operation may have been hiding out on and around present-day Park Island during the first year of the Civil War, not far from where Shaw would end up stationed. The undeveloped island, created in the 1850s when the bayou's most inefficient curve was lopped off by the Carondelet Canal and Navigation Company, would have been a relatively covert place to conduct this business. According to the *Times-Picayune*, a wooden-hulled, eight-hundred-ton gunboat called the *Bienville*, along with the *Livingston*, a naval steamer, were said to be in production there, although they were never completed.[147]

The bayou didn't see much action during the Civil War, perhaps, but it witnessed firsthand the tumultuous years to follow.

EXPANSION

In the 1870s and 1880s, the bayou's recreational character continued to develop even as it remained an important commercial corridor. In 1867, a City Railroad line laid down tracks along its banks. The city expanded its streetcar service, and by the mid-1870s, four different lines stretched from the city center to the neighborhoods surrounding the bayou's dogleg, which were gradually becoming more residential in nature.[148] The Spanish Fort Amusement Park continued to receive visitors by the hundreds. Even the bayou's swampy environs witnessed its fair share of activity: its cypress forests, particularly near Lake Pontchartrain, hosted numerous voodoo ceremonies in the 1870s. Marie Laveau—a real woman and a religious leader shrouded in layers of mysticism and lore—was voodoo's famous figurehead.[149] Although many white spectators believed they were witnessing voodoo ceremonies at Congo Square, historian Ina Johanna Fandrich says:

The "real" Voodoo rituals took place well concealed from public spectators in secret places in private homes or abandoned yards, or outside of the city along the shores of Lake Pontchartrain, in the oak grove of today's City Park, or in the nearby ciprière, *the cypress swamps, where the maroon societies were hiding out.*[150]

An 1883 view of the developing neighborhoods around the southern end of Bayou St. John. *Robinson's Atlas of the City of New Orleans, Louisiana, 1883, Plate 22. Dale N. Atkins, Clerk of Civil District Court, Parish of Orleans.*

Because these ceremonies were initially so remote and well hidden—due to the same swampy properties of the landscape that once sheltered runaway slaves—it has been difficult for historians to reconstruct what they entailed. And yet, by the 1870s, Marie Laveau's lakeside voodoo ceremonies had become major mainstream attractions. By some estimates, as many as twelve thousand New Orleanians, primarily white, would travel via railcar to Lake Pontchartrain near where it meets the bayou to witness the St. John's Eve festival (held the night before the Feast Day of Saint John the Baptist and claimed by Laveau for her annual ceremony) on June 24.[151] The city's newspapers obsessively covered these events, sensationalizing the ceremonies as "whiskey-wrought orgies,"[152] both "curious and disgusting."[153] Frandrich quotes Luke Turner, self-proclaimed nephew of Laveau, as he describes the St. John's Eve rituals "in a far more mystical way: 'Nobody see Marie Leveau for nine days before the feast. But when the great crowd of people at the feast call upon her, she would rise out of the water of the lake with a great communion candle burning upon her head and another in each one of her hands. She walked upon the waters

to the shore.'"[154] However, this moment of voodoo fandom among white residents was short-lived; the post Union-occupation backlash in the years to follow forced practitioners back into hiding.[155]

The lakeshore's relative wilderness also provided a safe haven for communities of newly freed black residents after the Civil War. Along the lakeshore, including near its intersection with Bayou St. John, these self-sufficient communities began to take root, an act undoubtedly in tension with the dominant power structure at the time. Distressed reporters for the *New Orleans Daily Crescent* described what had become of the "little fishing village situated at the mouth of the Bayou St. John; and which, in olden times, we had known as so thriving, and comparatively speaking, so prosperous."[156] These nostalgic feelings were then juxtaposed to "the totally altered social condition of our country," the quintessence of which could be seen at that very spot: "Here where we sought for repose, for recuperation, we have met the very acme of our sufferings, our painful anticipations."[157] The authors described the communities in great detail:

> *These erections, which we cannot describe, for the materials are nondescript, neither tree barks, nor shingle, yet not the hunter's huts of latanier leaves, are a repetition of what already we have noticed upon the high roads of the Gentilly region....What strikes the beholder of these new abodes of the freed folks, is the idea that these people have certainly a notion of leading an independent life, of cultivating some little bean or potato patch outside the already cultivated farms or plantations. Aye, they knew, or they feel, if nobody has instructed them, that they cannot encroach upon the lands of the planters or farmers; hence they build or patch up for themselves some unnameable shanties upon the high roads, in the very bayous, or outside the marshes, on the very shores of the lake, often under the surges, when at high water. Now, what does this signify? Are our local authorities to tolerate such a situation? Can we shut our eyes to the condition such a general example will lead if these disorganizing tendencies are not nipped in the bud?*[158]

Much like the maroon colonies that once cropped up in the swamps bordering the young city, these communities were deeply threatening to the status quo. The authors feared that in the untamed wilderness of New Orleans' outskirts, "in the immediate vicinity of our great metropolis," emancipated blacks would form long-term, self-sustaining communities, opting out of the labor system entirely. They warned that this phenomenon could take place throughout rural America. They continued, "We think

that this idea of every one's free way of living has its limits in a civilized community, and that our authorities have a right to abolish a system of Gypsy order, which, though it is not exactly vagrancy, still does not come up to regular work or labor communion."[159]

The swamp surrounding the city was little more than an embarrassment to New Orleans city leaders for more reasons than one, particularly as the nineteenth century drew to a close. Beyond its perceived pestilential dangers, both literal and social, it represented a barrier to the urban expansion necessary for any respectable metropolis. It *had* to be drained and developed, or else New Orleans would be left behind as all other American cities expanded and modernized. During the city's colonial era, drainage was attempted via manmade ditches and outflow canals; by the middle of the nineteenth century, the city's drainage system had grown to include four huge steam-operated paddle wheels called "draining machines" that would shunt excess water out to the lake. The Bienville draining machine, located just below where the bayou currently terminates, at the intersection of Jefferson Davis Parkway and Bienville Street, was considered the center of the drainage system but had fallen into a state of disrepair by the end of the Civil War.

In the 1890s, the city undertook its most concerted drainage effort to date. What resulted was the construction, beginning in 1896, of a vast network of gutters, pipelines, drains and canals hundreds of miles long, servicing twenty-two thousand city acres through the use of six new pumping stations. The new drainage system would receive a powerful boost when highly efficient "screw pumps," invented by engineer Albert Baldwin Wood, were installed in 1915. But even by the turn of the century, the city of New Orleans had finally won its war against the swamps, and the years between 1900 and 1940 would be defined by a dramatic land rush toward the lake. The swamps skirting the bayou's winding torso would be transformed in a matter of decades into manicured neighborhoods and subdivisions.[160]

The development of City Park as we know it today, which kept pace with the city's drainage developments, is representative in many ways of the city's fast-paced progress around the turn of the century. Baltimore native John McDonogh, known for his generous bequests to establish a public school system in New Orleans, purchased the Allard plantation (which comprised the present-day lower portion of City Park) in 1845. Upon his death in 1850, the city, in response to growing public desire for such urban improvements, decided to turn a portion of this land into a public park. A *Times-Picayune* article from 1851 described the benefits of such a space:

The plan we have above spoken of lays down sufficient space for a large public park in the rear of the First Municipality. The experience of all large cities has proved completely the absolute necessity of these places of public resort….We are not over-provided with public squares; and we have none worth of being called a public park, where our citizens can walk, drive or ride, and enjoy the shade, the cool breeze, and the pleasure of grounds well laid out and neatly kept.[161]

While steps were taken in the 1850s to improve the land, and while the proto-park was indeed frequented by visitors, the Civil War put a stop to these developments.[162] According to Catharine Cole, writing for the *Daily Picayune* in 1892, by the late 1860s, "the City Park stood abandoned, desolate, and mysterious," populated by roving cattle, untamed weeds and the occasional "stealthy suicide [who] crept out to its coverts and nourished the roots of its great oaks with his blood."[163]

During the last decade of the nineteenth century—as the women's rights movement was gaining momentum, at the height of the bicycle craze and as the public began calling out for a serious drainage solution—City Park as we know it today began to take shape. In 1891, the City Park Improvement Association (CPIA), made up of businessmen and local politicians (most of whom were residents of the Bayou St. John, Mid-City, Esplanade Ridge and Faubourg Marigny neighborhoods), formed with the goal of making improvements to the present-day City Park area.[164] With mandated annual funding from the city, the Board of Commissioners of the CPIA facilitated tending to the park's massive live oaks, filling in low-lying areas with thousands of tons of shells, laying gravel walkways, constructing fences and building dancing pavilions, benches, picnic clearings and "rest houses." Bayou Metairie, the remnants of which trickled lazily through the center of the property, was transformed into a lagoon complete with islands and footbridges, fed via outflow pipes by the waters of Bayou St. John. By 1898, the CPIA had nearly doubled the size of the original tract (although the entire stretch of present-day City Park would not be acquired until 1927). A *Daily Picayune* article from 1900 boasted, "From an unattractive, swampy waste [City Park] will become an undulating expanse, above the swamp level, surrounding a series of miniature lakes."[165] Soon enough, Bayou St. John would be swept up in City Park's embrace like its sibling waterbody Bayou Metairie. But as the nineteenth century came to a close, it served merely as the eastern boundary of the park's growing trunk, ushering goods-laden traffic from the lake to the edge of the French Quarter and back again.[166]

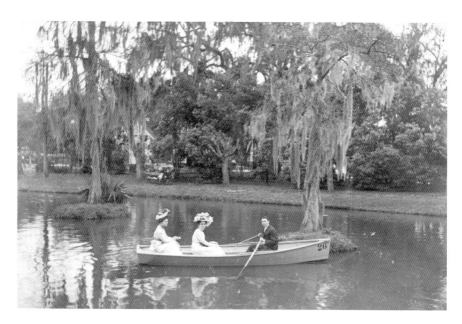

Visitors rowing in a City Park lagoon, sometime around the turn of the twentieth century. *Harry D. Johnson Photograph Collection, Louisiana Division, New Orleans Public Library.*

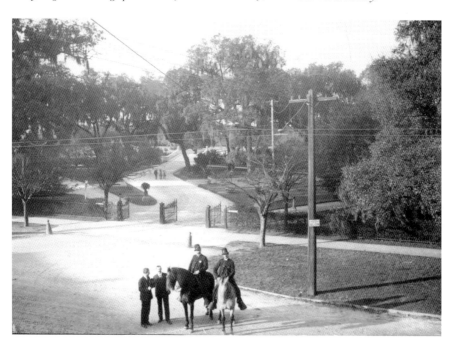

Men near the entrance of City Park, along present-day City Park Avenue, circa 1890–1910. *Charles Milo Williams Photograph Collection, Louisiana Division, New Orleans Public Library.*

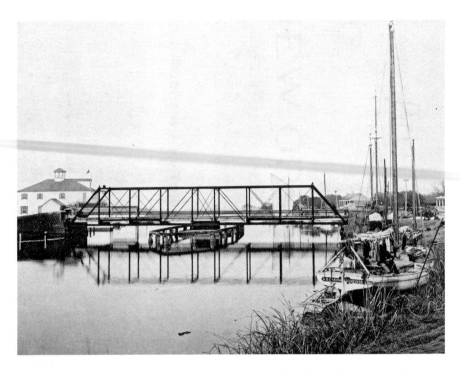

Fishing boats near the Esplanade Bridge, 1895. *Bayou St. John Vertical File, Louisiana Division, New Orleans Public Library.*

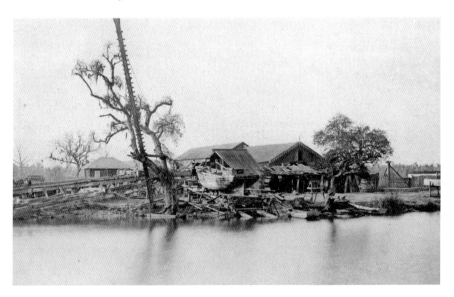

Shipyard near the bayou's intersection with Lake Pontchartrain, 1895. *Bayou St. John Vertical File, Louisiana Division, New Orleans Public Library.*

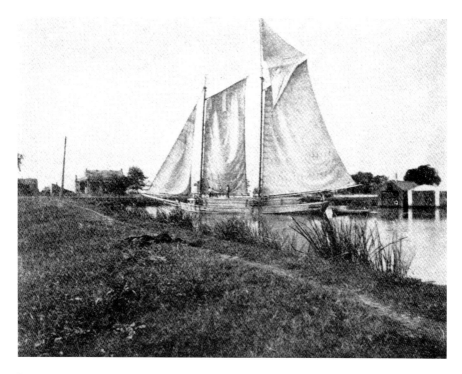

Lumber schooner along Bayou St. John, around the turn of the twentieth century. *Bayou St. John Vertical File, Louisiana Division, New Orleans Public Library.*

If you were to stand at the intersection of Esplanade and Moss at the end of the nineteenth century, you would be surrounded by the hustle and bustle of a space both industrial and recreational. Newly electrified streetcars would lumber past on their way to City Park or other lakeside destinations. Perhaps bridge tenders would arrive on either bank and stop traffic, swiveling the Esplanade Bridge to allow a ship to pass. Along the bayou's banks stand a few modest houses, guarded by wooden fences; a shipyard, with the upside-down skeleton of a vessel in progress propped up on stilts; and grassy slopes leading down to the water, where sloops sit moored with their sails down, dinghy-flanked. If you were to turn around and look down Esplanade, you would see the magnificent houses of some of the city's wealthiest residents lining the leafy thoroughfare. Homes of all shapes and sizes would be visible along Esplanade's cross streets. A well-dressed family might ride past you in a horse-drawn carriage, speaking Parisian French. A jockey might saunter past you on his way to the racetrack. Across the way, City Park's manicured lagoons and moss-

draped oak trees would teem with visitors, strolling and picnicking and tossing bread to the swans. In the distance, to the north, the swampy expanse would be punctuated only by droopy cypress trees. If you were to stand there long enough, however, looking off into the distance, you might even be able to witness the swamp's disappearance—the park's slow, civilizing crawl toward the lake.

BAYOU ST. JOHN AQUATIC PARK

1900–1950

During the first half of the twentieth century, as City Park continued to develop and the waterway's days of commerce came to a close, the fate of the bayou and the Old Basin was deeply uncertain. Questions around use and control that emerged during this era epitomized the dynamism at the heart of the relationship between the public and its waterways—resulting in possibly the most contentious twenty-five years of the bayou's history.

HOUSEBOATS AND LAWSUITS

The early years of the twentieth century witnessed a fast-paced modernization of the drainage system implemented citywide in the 1890s, aided by Woods's high-efficiency screw pumps. The system soon rendered desirable all of those "back of town" neighborhoods previously considered wild and uninhabitable. Soon enough, streets were cut and pilings were plunged through the recently drained river sediment of Mid-City, Lakeview and Gentilly. In both Gentilly and Lakeview, deed covenants limited homeownership to whites only. Ads promised some of the city's most "delightful" and "valuable" neighborhoods with advantages of both urban and country living.[167]

Development of City Park around the turn of the century continued at full steam ahead. Under the supervision of Paul Capdeville, president of the Board of Commissioners of the CPIA and mayor of New Orleans

A 1929 photograph of one of the Sewerage & Water Board's new fourteen-foot Wood screw pumps, the largest ever built. *"Image of the Month," July 2003, Louisiana Division, New Orleans Public Library.*

from 1900 to 1904, sewerage, running water, electrical and gas systems were installed in the park; streetcar lines and roadways were extended and modernized in order to maximize public use; and the stretch of Metairie Road between Canal Street and Esplanade Avenue was widened and renamed City Park Avenue.[168] A 1913 article published in the *New Orleans Herald* provides a fine description:

> *The lake* [in the park] *is stocked with all sorts of fish and the public is allowed to use rod and reel under certain rules, and for a moderate charge. Boats can be hired for a trip on the lake....The park now has beautiful shelled drives, walks and avenues; a peristylium, a carousel, skating rink, dancing platform, deer pen, hothouse, many buildings for the comfort and entertainment of the public and abundant water for drinking purposes, both from cisterns and waterworks mains. The park is admirably managed, policed and taken care of, and it is a most favorable resort for families, and for school picnics.*[169]

In 1909, at the other end of the bayou, the New Orleans Railway and Light Company purchased the site of the Spanish Fort Amusement Park. The park had been abandoned by rail service in 1903 and ravaged by fire in 1906, and the company soon undertook rebuilding it, adding a Ferris wheel, a theater and other concessions.[170] By 1926, after years of drawing considerable crowds, the amusement center at the old Spanish Fort site had closed for good, giving way to the Pontchartrain Beach Amusement Park in 1928, located to the northwest of the original Spanish Fort site along the lakeshore.[171] The beach would extend several hundred feet and include a small park, bathhouses, concessions, refreshment stands, lunchrooms, vaudeville acts and mechanical rides with names like the Bug, the Flying Horses, the Whip and the Laff in the Dark.[172] Meanwhile, black residents were relegated to Lincoln Beach in eastern New Orleans until the 1964 Civil Rights Act took effect.[173]

New Orleans' rapid expansion toward the lake during these years began to be visible in microcosm along the bayou's banks. In 1904, Captain Salvatore Pizzati, an Italian philanthropist and fruit merchant, donated $75,000 for an orphanage on Esplanade Avenue to be run by the Missionary Sisters of the Sacred Heart. Mother Frances Xavier Cabrini, founder of

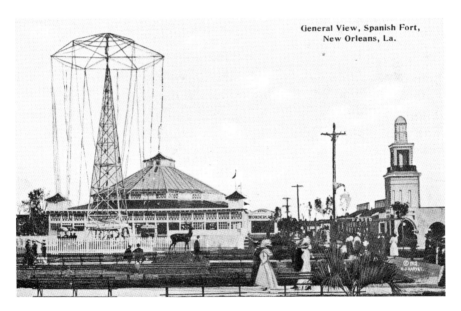

Spanish Fort Amusement Park, 1912. *From Louisiana Postcard Collection, Louisiana Division, New Orleans Public Library.*

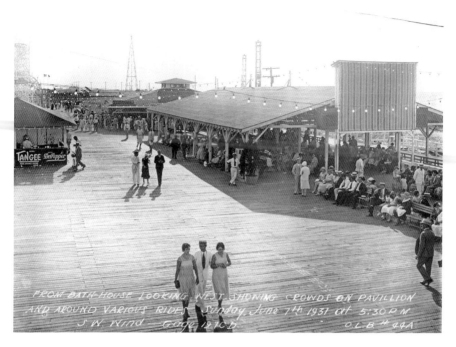

The Pontchartrain Beach Amusement Park, 1931. *Elam (Edwin Essex Sr.) Collection, Earl K. Long Library, University of New Orleans.*

the congregation and the first American saint, had opened an orphanage for Italian immigrants on St. Philip Street in 1892 in the heart of the lower French Quarter's "Little Palermo," home to a large Sicilian population from the 1870s on.[174] The new school, to be erected in a lot bordered by Moss Street and Esplanade Avenue, was intended "to educate and Americanize" orphans and poor Italians outside of the congested French Quarter and would come to include a chapel, study rooms and apartments.[175] In 1959, this complex was reborn as Cabrini High School, still in operation along the bayou's banks today.[176] By the middle of the century, Italians and other groups previously clustered around New Orleans' downtown would flock lake-ward, embracing the suburban living made possible by drainage.[177]

While residential development in the area surrounding the bayou was undeniable in the early 1900s, the waterway struggled to remain commercially relevant. Nonetheless, the *Times-Picayune* reported that in 1903, tugs, schooners and luggers of all sizes transported goods like lumber, charcoal, bricks, sand, shells, firewood, shingles, oysters and miscellaneous produce along the waterway's length from the lake to the French Quarter and back

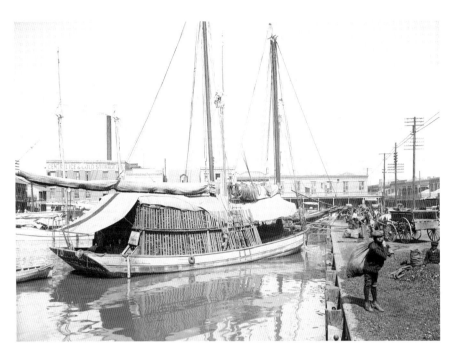

Charcoal boats in the Old Basin, circa 1906. *Library of Congress.*

again. From August 1, 1902, to July 31, 1903, more than ten million feet of lumber, seventy-nine thousand barrels of sand, sixteen thousand barrels of shells and twenty-two thousand barrels of oysters, among other products, traveled along its course. Along the Old Basin's banks in particular, industry had been steadily increasing, predominantly fueled by black and immigrant labor. Companies like C.N. Maestri Furniture Manufacturing Company, Jacob's Pottery, Crescent City Fireworks Company and Crescent City Moss Ginnery, as well as numerous ice plants, shipyards and lumberyards, lined the canal's banks, particularly around the turning basin. While the New Basin was trumpeted as "the most important artificial waterway in Louisiana, so far as the volume of traffic is concerned," a good argument could still be made for the commercial viability of the Old Basin as well.[178]

New recreational pastimes were also beginning to develop, perhaps because there was enough room for them given the bayou's relatively light traffic. As an alliance of pleasure boaters in 1906 claimed,

> *Canoeing, within the past year, has taken a big impetus in New Orleans,*
> *and scarcely a night passes but a number of these graceful bateaux are to be*

seen gliding silently over the surface of the bayou. Nearly every week new motor craft are added to the already large fleet in these waters, and some of the handsomest and most costly pleasure craft of this kind are to be found in New Orleans as their home port.

The New Basin Canal, it went on, was too "congested with commerce," and so small pleasure craft turned to the "historic Bayou St. John" instead.[179]

Although commerce on the waterway would have continued to decline as the twentieth century progressed, given both citywide and national trends, a particular event brought this issue to a head in 1907. That year, the Carondelet Canal and Navigation Company's charter for operating the waterway commercially, which it had been been doing since 1857, expired. The Carondelet Canal and Navigation Company (CCNC) had taken control of the waterway after the Orleans Navigation Company (ONC), founded by James Pitot in 1805, lost its charter in the 1850s.[180] According to the CCNC's charter, the canal and bayou would revert to the state in 1907. But when the state attempted to step in to regain control in 1908, the CCNC responded by demanding compensation for all improvements made to the waterway over the course of its fifty-year tenure.

In the lawsuit to follow, the CCNC argued that the state had never owned the land the Old Basin cut through to begin with—that Governor Carondelet had assumed he was dredging a canal through land owned by the Spanish Crown, but the land had instead been owned privately. It maintained that when the Orleans Navigation Company stepped in to re-dredge the canal in 1805, property owners had emerged saying that Carondelet hadn't had a right to put it there in the first place. According to the CCNC, the ONC purchased the land outright before proceeding, and the CCNC itself had purchased the land in good faith in 1857 in a sale facilitated by the Louisiana legislature. Furthermore, the company maintained, a legislative act of 1858 that added to the conditions of the original charter stipulated that "it" would only be returned to the state at the end of the charter if the state were to compensate the CCNC for improvements. Significant confusion surrounding the exact meaning of this "it" resulted in the suit going all the way to the Supreme Court.[181]

This protracted transitional moment, in which no entity was exercising (consistent) jurisdiction over the waterway for close to twenty years, had profound physical and symbolic implications for the bayou. While the courts attempted to untangle the lawsuit, and even once a decision had been made, the bayou was under questionable, or at least contestable, supervision. In the

Former site of the Orleans Navigation Company headquarters, as evidenced by stonework above windows. *Joseph Bauer Family Album Collection, Earl K. Long Library, University of New Orleans.*

vacuum of authority that ensued, the corridor's condition began to deteriorate, which in turn fueled discussions surrounding what its functional future would be, if it was to have a future at all. How should it be utilized—for commerce, recreation or both? And given those functions, who should be permitted access to its waters, and at what price? Was the waterway primarily commercial in

function, as defined by its manmade leg? Or was it recreational in nature, as defined by the natural Bayou St. John? Should the state, once it takes over, invest in commercial improvements? Or did the bayou's unique history mean the city ought to beautify and preserve it for recreational use? During those critical years, tentative alliances were formed between parties with a stake in the waterway's use—the CCNC, the city, the state, the Army Corps, City Park, the Bayou St. John Improvement Association, pleasure boat owners, shipyard owners and residents—a sustained cacophony surrounding a waterway growing more sluggish and inefficient by the minute. Its revetments were crumbling, its waters were choked with algae and hyacinth and the area where it meets the lake had grown almost too shallow for even the smallest boats to traverse. And perhaps most noticeably of all, a veritable floating colony had sprung up along its stretches—a thick chain of privately owned houseboats, boathouses, shipyards and wharves lining its shores like a patchwork necklace.[182]

While the lawsuit between the CCNC and the state made its way up through the courts, several conflicts arose over uses of the bayou that serve to illustrate explicitly some of the key questions being posed at the time. The CCNC, while awaiting the compensation it felt it was owed by the state, instituted new taxes on boat owners for utilizing the waterway. Bayou St. John boat owners wasted no time in fighting the proposed tax, employing the

Motorboats, houseboats, boathouses and other structures along the bayou's banks in the early years of the twentieth century. *From author's postcard collection.*

Houseboats and boathouses along the bayou, 1910. *Library of Congress.*

argument that the bayou was under jurisdiction of the secretary of war as a free and navigable waterway and that no entity had the right to obstruct it or demand tolls.[183] On July 11, 1908, for example, a group of Bayou St. John pleasure boat owners filed an affidavit on behalf of Captain J. Bart Davis, owner of the launch *Savannah*, against Captain W.P. Nicholls, superintendent of the Canal Company. According to the affidavit:

> *On the 14th of June, while attempting to pass under the bridge with his boat on the way to the lake,* [Captain Davis] *was prevented from proceeding by a chain under the bridge entirely across the bayou, from the shell road side to the Spanish Fort side. The keeper of the bridge hailed witness and asked him if he had a permit, or if he would pay the toll of 5 cents per running foot for a month's permit. Witness replied that he had no permit and would not pay. Thereupon the keeper refused to lower the chain.*[184]

W.P. Nicholls was eventually arrested. U.S. Commissioner Henri Chiapella, after tracing the waterway's history back to its beginning, ultimately ruled the state had never had a right to lease the bayou to the

ONC in the first place. The bayou's role in the founding of the city, the fort at its mouth and the so-called "Spanish Custom House" built near its base were all cited as proof of the bayou's value "for commercial and military purposes."[185] Its commercial and military value served to prove its status as a navigable waterway under jurisdiction of the federal government. This case would be referenced in future years to prove that the bayou was indeed "a navigable stream, forming part of the navigable system of water courses which are common highways of the United States."[186] In the immediate, however, the decision seemed to have little effect on the bayou's future.

Or take, for example, a March 1909 *Times-Picayune* piece in which an irritated resident complained about boathouses and houseboats, "that long line of eye-sores," along the bayou. He maintained they'd been erected without permission, and without anyone stepping in to forbid it, people would soon be living in the structures permanently. They were eroding the bayou's once-sophisticated character:

> *Apparently, it will be only a short time, unless a halt is called prohibiting the further erection of these houses, and those already there are demolished or removed, until beautiful and picturesque Bayou St. John will be no more, and will, no doubt, be known as "Shabby" Bayou St. John, which name is it fast acquiring, due to those cheap looking boathouses now thereon.*[187]

Another *Times-Picayune* opinion piece from June 1913 struck a similar tone. According to the article, neither the Indian nor the early French *voyageur* would be able to recognize the bayou they once knew. Moreover, the Old Basin could never be compared to the canals of Venice or Amsterdam, the author maintained, given the "old schooners and yawls, all filthy and all manned by motley crews of dark Spaniards and Italians" tying up to unload along its banks.[188] Meanwhile, if an observer were standing in the right spot, he might conclude that the waterway was the primary "path to the lake of New Orleans pleasure sailors," given the one-hundred-foot yachts and graceful sailboats, white-painted and brass-burnished, tied up near the Esplanade Bridge. Or else, a houseboat colony. Or else, a motorboat heaven. Midway between Spanish Fort and City Park, by contrast, the bayou looked largely as it did to the Indian and the *voyageur* two hundred years before, wild and undeveloped in its middle stretches.[189] The waterway haphazardly maintained these various identities for the next fifteen years or so, even once *the State vs. CCNC* had been settled.

In June 1910, it had looked as if all was decided, at least in legal terms: the Louisiana Supreme Court awarded control of the waterway to the state, overturning a lower court order ruling in favor of the CCNC's plea for compensation. The Louisiana Supreme Court ruled that the "it" in the 1858 act referred merely to a railroad the company had been given permission to build along the canal, but which it never had. Therefore, the CCNC was owed no compensation at all, and the state could regain control of the waterway immediately.[190] But the CCNC was not satisfied: in July 1911, the *State vs. CCNC* went to the U.S. Supreme Court to be decided once and for all. Three years later, in April 1914, the justices awarded the CCNC victory, ruling that the state would have to pay an agreed-upon value for improvements made to the waterway between 1857 and 1907. The "vagrant 'it,'" the Supreme Court maintained after consulting a version of the document in French, referred not to the railroad but instead to the entire waterway, and the state would be required to compensate the company for any and *all* improvements to the corridor made during its tenure. The state was ordered to enter into negotiations regarding the value of improvements or else allow the CCNC to maintain control indefinitely.[191]

In the aftermath of the Supreme Court's decision, while the state worked to get the payments together ($300,000 when all was said and done[192]), the CCNC liquidators swept in to levee new tolls on boat owners using the waterway. Funds had to be raised to keep up with the waterway's maintenance.[193] Those who had been refusing to pay tolls during litigation, spurred by boat owners' associations, had to settle up. Boathouses had to be removed at once: placards lining the bayou warned that if owners didn't demolish their boathouses, wharves and landings, the CCNC would do it for them. According to the commissioners, only two boathouses out of many dozens had been erected under the proper authority. All the rest, many of which had cropped up between 1908 and 1914, lining the banks so thickly "as to obstruct any possible landing," hindered navigation, invited unruly crowds, were dangerous in construction and "unsightly to the extreme."[194] Some guessed that they were even being used as permanent dwellings; others cited incidents in which boathouse owners supposedly threatened Sewerage & Water Board employees with shotguns if they put pilings too close to their structures.[195] The City Park Board took this opportunity to leap in and call for the removal of houseboats as well—those "public nuisance[s] which should not be tolerated"—in the hopes that the bayou's shores forming the eastern edge of the park would become visually pleasing. City Park commissioners argued that the waterway was a navigable stream and

that "no one has the right to erect permanent structures within its banks."[196] Again, the bayou's status as a navigable waterway was invoked. Effects of the CCNC liquidator's demands are difficult to ascertain, however, since sources confirm that houseboats and other structures remained in the bayou well into the 1940s.[197]

To add another factor to the equation, in the immediate aftermath of World War I, a key development downriver would come to affect the overall fate of the corridor. From 1918 to 1923, the Inner Harbor Navigation Canal, or "Industrial Canal," was sliced through New Orleans' Ninth Ward. The canal connected the river and the lake, a feat originally proposed for the newly dug Carondelet Canal at the end of the eighteenth century, but the inability to reconcile the difference in water levels between the lake and the river had contributed to the early plan's ultimate failure. Meanwhile, the Industrial Canal, far more efficient than the New and Old Basin Canals, would soon render them both obsolete.[198]

By 1925, for reasons that are not entirely clear given a dearth of accurate sources on the matter, the city, as opposed to the state, made the first of several payments to the CCNC in order to purchase the Old Basin. The bayou was left out of this equation, perhaps because its singular status as a navigable waterway meant that the state already owned it.[199] By this point, the Old Basin and the bayou were in reportedly terrible condition, and yet, as late as the early 1920s, arguments were still being made that if the federal government would simply commit to dredging the bayou's mouth, the Old Basin could at least once again parallel the traffic of its younger sibling.[200] Walter Parker, judge and former manager of the New Orleans Commerce Association, was a prominent fighter for the bayou's mixed-use future.[201] Others chimed in, envisioning the waterway becoming one of the city's "beauty spots": it would be declared a historic waterway in a city newly embracing the preservation of its iconic landmarks.[202] Once again, nostalgic residents referenced the bayou's days as home to "fine homes" and "gay parties," simultaneously denigrating its "scum-like growth," unkempt banks, "dilapidated shacks," sporadic sidewalks, wild gardens and shabby old houses.[203] If it were improved, beauty and commerce could exist alongside each other.[204] No matter what its future would be, one thing was clear to all involved: the waterway was "in such condition as to constitute a nuisance." It needed to be "cleaned up or closed."[205]

NEW BEGINNING, SAME QUESTIONS

In 1927, the same year City Park acquired a nine-hundred-acre tract of land extending all the way north to the lake, the Old Basin was declared officially unnavigable.[206] No improvements had been allocated to the waterway; by 1938, it was completely filled in. The bayou was once again unencumbered, and its destiny appeared to tip toward the recreational and historical, although it was still used for the modest commerce necessitated by the few remaining lumberyards and shipyards along its banks. In 1926, Bayou St. John property owners, led by Parker, formed the Bayou St. John Commission. Organized in order to advocate for the waterway's "beautification," the commission appealed to the City Park commissioners, who were more than willing to try and help rid the bayou of its "squatters" and to support other beautification measures. Parker waxed poetic, according to this 1926 *New Orleans States* article, at one of the early meetings attended by neighborhood groups and other interested parties:

> *Why should not soft lights and sweet music please the eye and ear of New Orleans along Bayou St. John?...Why should not flowers border the levee top walks? Why should not canoes replace the wreckage? Why should not pergolas and pleasing landings replace the tumble-down boat housing in front of our homes? I assure you the city government, the levee board, the parking commission, the City park [sic], and every other municipal, state and federal authority will help us in every practical way. But we must supply the inspiration, the leadership.*[207]

And so the bayou's makeover commenced. It may have lost its manmade leg, but the bayou itself was about to be so altered by manmade improvements that, soon enough, few of its natural properties would remain.

The Bayou St. John Commission's plan, set down in 1929, was to transform the bayou into an aesthetically pleasing aquatic park—which would involve widening it in places, constructing a yacht harbor near its intersection with the lake and establishing, in the bayou's southern stretches, water sports, rowing races, tea gardens and eateries.[208] Its plan also involved, unsurprisingly, ridding the bayou of houseboats and other shoreline structures once and for all. This time, Parker reinvigorated efforts by seeking help from the War Department, to little avail. The *New Orleans States* reported:

As a result of the recent announcements in regards to the improvement program, "squatters" have not only refused to become evanescent, but, on the contrary, have attained prominence along the bayou banks to a degree never known heretofore, according to Mr. Parker. One enterprising gentlemen contemplates construction of a super-water garage. In his letter, Mr. Parker further claims that the war department has sole jurisdiction over the bayou: that the war department, nevertheless, will not act.[209]

In fact, no agency seemed willing to claim jurisdiction over the bayou, particularly when it came to the houseboats. According to Parker, they had been allowed to exist in the first place because the city and the state did not exercise jurisdiction and because the federal government stood aside and refused to exercise it because a private company, the CCNC, had control of the waterway at the time.[210] The U.S. Army Corps maintained that issues of policing were the city's responsibility, but the city claimed to never have had police authority over the waterway; the Levee Board claimed jurisdiction only over the levees.[211] Parker then appealed to the New Orleans Board of Health. When the board of health conducted an inspection of a group of nineteen houseboats on the bayou in 1927, all but two of them were being used as permanent residences for over fifty individuals in total.[212] The board then issued notices to the inspected houseboats, demanding that their owners install proper sanitation facilities to avoid polluting the bayou. (Many houseboats had electricity and telephone lines but no sewage plumbing.)

Meanwhile, the Bayou St. John Commission facilitated the removal of decades worth of debris from the southern end of the bayou, which included sunken structures and vessels—like the partially submerged fishing schooner *Mabel*, the hulk of which was dynamited in 1928. Even given these accomplishments, however, early attempts at coherent bayou beautification by Parker and the commission remained hampered by jurisdictional confusion. It took the collapse of the Esplanade Bridge in 1929, after only twenty-one years in service, to catalyze real change.[213]

The bridge, which had collapsed when lifting to allow a lugger to pass, trapped a veritable cross section of bayou watercraft. According to *Historic City Park, New Orleans*:

20 boats and 2 shipyards now lay trapped....Six were used for business—the 30 foot sloop "Hero," which towed logs; the 40 foot lugger "Royal Queen," the 35 foot launch "Ory M" which belonged to the Mullens Shipyard; the

40 foot steamer "Dupuy," belonging to Dupuy's shipyard, and the 48 foot launch "Ethel Louise," also Dupuy's. The bridge collapse also stranded a 75-foot steam yacht, the "Florette," used as a houseboat by its owner.[214]

The collapse begged the all-important question of whether or not the new bridge at Esplanade ought to be "a 'fixed' one" or whether it should be replaced with another drawbridge that would allow for the passage of larger craft, commercial or otherwise. Given the recreational character the commission and others had in mind for the waterway, a fixed bridge would have been ideal for transforming the bayou south of Esplanade into a recreational haven for small craft only. Shipyards and owners of larger boats, on the other hand, protested against the idea of a fixed bridge, citing the bayou's status as a navigable stream under ultimate jurisdiction of the Army Corps of Engineers.[215] After a year or so of fierce debate, the corps weighed in, allowing for a fixed bridge at Esplanade with the understanding that the northern reaches could still be used commercially.

Meanwhile, the commission, with help from prominent businessmen and other influential citizens, facilitated the passage of a 1934 act that gave control over much of the bayou to City Park—which included the right to ban all boathouses and other shoreline structures.[216] Finally, as *Historic City Park, New Orleans*, describes, "the combined political muscle of City Park, [Mayor] Behrman's Choctaw Club Fifth Ward Association and Old Regular Democrats succeed in getting Works Progress Administration funding to convert Bayou St. John into an aquatic park."[217] Beginning in 1935, the WPA facilitated the major changes to the bayou visitors still see today. Concurrent with WPA efforts unfolding citywide, including in City Park and at Spanish Fort, workers removed organic debris, cleaned out refuse, dredged and excavated mudflats and blasted cypress stumps. In order to do so, they closed the locks at the lake end of the bayou and opened the drainage valve at its base to lower the water level, exposing its trash- and mudflat-strewn bottom. They removed the bayou's "weed mat" with rakes, set about killing algae and hyacinth, planted shrubs and trees along the banks and graded and widened the streets running alongside. They both deepened and straightened the bayou in places, repairing revetments along the way. The idea was to remove the "ugly spots" along the bayou's banks and transform them into "pleasing spots," replacing the hodgepodge mess of private wharves with the uniform public boat landings still visible today.[218]

In 1936, spurred by the Bayou St. John and City Park Commissioners, an Act of the Seventy-Fourth Congress declared the bayou "a non-navigable

stream," putting an end to any and all commerce along its stretch due to "the immaterial value of Bayou St. John…as a highway of commerce for trade and travel by water…"[219] According to Mark Davis, director of the Tulane Institute on Water Resources Law and Policy, the ultimate legal effect of this act is somewhat tenuous. It appears to have exempted the bayou south of Esplanade Avenue from the reach of the Rivers and Harbors Act of 1899 which made it illegal to dam a navigable stream without a permit from Congress. This exemption would make it easier to install fixed bridges along this stretch of the bayou, essentially limiting its use to craft small enough to slip beneath the proposed six-foot clearance. However, this act would not change the bayou's status as navigable under state law, change ownership of the bayou by the state or remove the bayou from federal commerce clause jurisdiction, which gives the federal government the right to regulate navigable waterways.[220] Nonetheless, with the passing of this bill, the scant commerce that remained after the closure of the Old Basin came to a final halt. Both shipyards south of Esplanade were ultimately purchased or moved by the city. All houseboats south of the "Black Bridge," a few blocks north

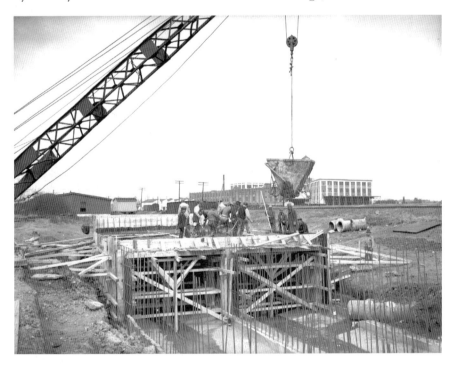

WPA workers constructing a concrete box culvert over Orleans Canal at Jefferson Davis Parkway. *WPA Photographs Collection, "Bridges," January 28, 1939. Louisiana Division, New Orleans Public Library.*

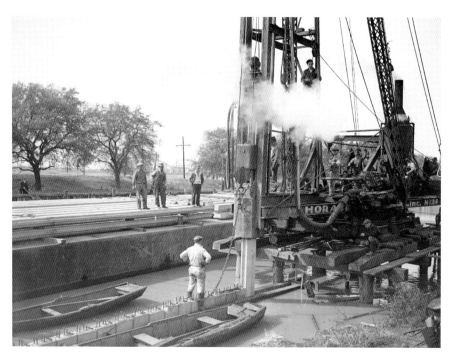

WPA workers placing concrete pilings in Bayou St. John. *WPA Photographs Collection, "Levees," March 1, 1937. Louisiana Division, New Orleans Public Library.*

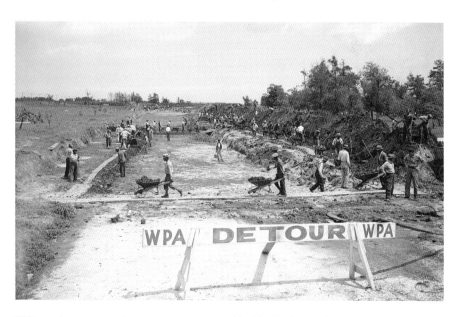

WPA workers constructing a new concrete road in City Park extension. *WPA Photographs Collection, "Parks," April 22, 1937. Louisiana Division, New Orleans Public Library.*

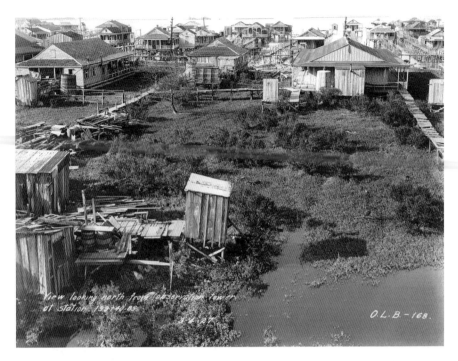

Bathhouses and fishing camps along Lake Pontchartrain before the Lakefront Project. *Elam (Edwin Essex Sr.) Collection, Earl K. Long Library, University of New Orleans.*

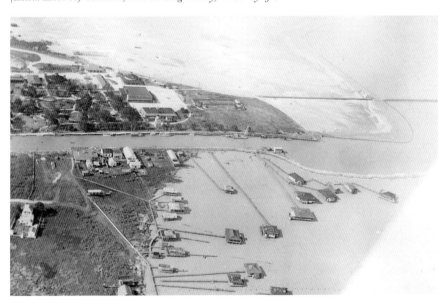

Fishing camps surrounding where Bayou St. John meets Lake Pontchartrain, before the Lakefront Project, circa 1948. *"Image of the Month," September, 1998. Louisiana Division, New Orleans Public Library.*

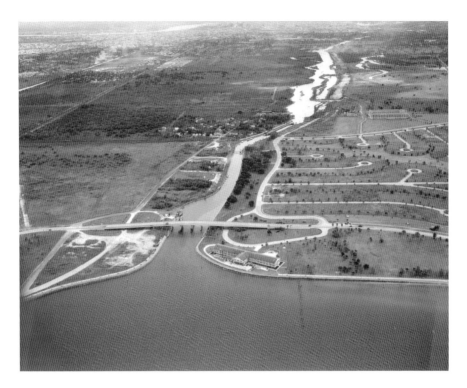

Bayou St. John's intersection with Lake Pontchartrain, after the Lakefront Project. *Abe Shushan Collection, Earl K. Long Library, University of New Orleans.*

of Esplanade Avenue, were removed. The state compromised with shipyard owners by offering the bayou north of Black Bridge for commerce, and the Levee Board obliged by building a high-rise bridge, with enough clearance to allow the passage of larger craft, at Lakeshore Drive.[221]

As if to echo the bayou's beautification, the south shore of Lake Pontchartrain, from the Jefferson Parish line to the Industrial Canal, was utterly transformed between 1926 and 1934. The ambitious Lakefront Project was designed to protect the expanding city from storm-driven lake surges while at the same time creating high ground for neighborhoods and public parks. The lakefront was transformed from, as Campanella describes it, a marshy "shantytown of fishing camps and jerry-built shacks" to a grassy high ground reinforced with a five-mile-long seawall.[222] The "reclaimed" land spawned new residential neighborhoods such as Lake Vista, Lakeshore, Lake Terrace and Lake Oaks. Pontchartrain Beach, the amusement park located near Spanish Fort starting in 1928, was relocated in 1939 to the end of Elysian Fields Avenue (the site of the present-day University of

New Orleans) on newly reclaimed land. Due to the reclamation, lakefront neighborhoods have a completely different atmosphere than the rest of the city.[223] "In utter contrast to the old riverfront city, Lakefront New Orleans today is spacious, sprawling, suburban, relatively prosperous and privy to expansive horizon-wide vistas of water and sky. It presents a subtropical coastal ambience associated more with modern-day coastal Florida…than with historic riverine New Orleans," Campanella explains.[224] It was as true then as it is now.

WORLD WAR II

Although newly beautified, the bayou had one last job to do. New Orleans as a city played a significant role in World War II, with its neighborhoods enjoying specific parts. Along the new lakefront, a Naval Air Reserve Air Base was built among several other military facilities.[225] Implicated in this use of the lakefront, the bayou served as a testing area for the famed Higgins landing craft. Designed by Nebraska-born Andrew Jackson Higgins, these amphibious landing craft and PT boats—initially designed for fishermen traversing Louisiana's shallow bayous—could "crawl" smoothly up the sandy shores of less fortified beaches, releasing invasion troops.[226] Originally a small plant employing around seventy-five men on St. Charles Avenue, Higgins Industries ballooned into a major defense contractor during the war, employing twenty thousand workers in eight locations across the city. One of the larger plants was located on City Park Avenue, where Higgins landing craft were constructed on a moveable assembly line before being loaded onto freight cars and chugged out to the bayou, where they were launched and tested in the lake.[227] Higgins boats activity temporarily revived the bayou's remaining shipyards, but once the war came to a close, according to *Historic City Park, New Orleans*, efforts to erase the bayou's unsightly past were started anew.[228]

If you were to stand at the intersection of Esplanade and Moss in the late 1940s, you would see evidence of rapid change all around. Behind you, Esplanade would be teeming with automobiles and streetcars, carrying passengers to and from City Park and the Fairgrounds. A group of children might skip by, shouting in Italian to one another, on their way to Terranova's Italian Supermarket, founded in 1925.[229] A woman would perhaps be sitting on her front porch nearby, reciting the Rosary in French.

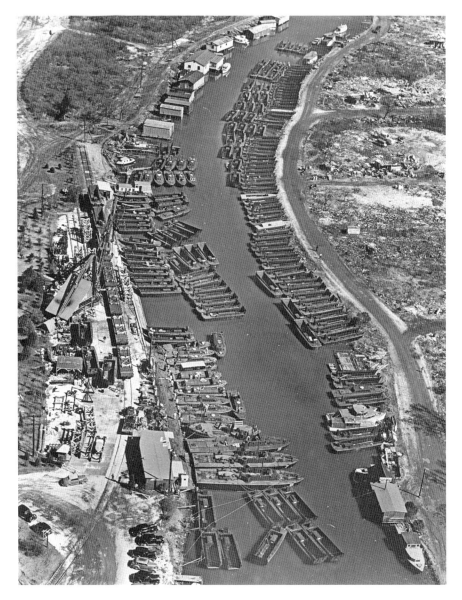

Higgins boats in Bayou St. John. *Collection of the National WWII Museum, IRN: 164188.*

A dark-skinned man would perhaps walk by, dressed in coveralls and a newsboy cap, on his way to work. Before you, a new fixed bridge would span the bayou, stately and shining, having replaced the former narrow drawbridge at the end of Esplanade Avenue. The waterway would look

clean and secure, lined with levees and concrete boat landings equipped with iron rings and landscaped banks. A canoe might pass by, its belly filled with fair-skinned young people and their picnic lunch. To your right, toward the lake, a few larger sailboats might ply. And if you were to listen closely, you might hear the sounds of neighborhoods growing all around you—Mid-City, Gentilly and Lakeview—trees crashing, pile drivers slamming, saws whirring to life.

BAYOU ST. JOHN IN THE MODERN ERA

1950–2017

Despite the Bayou St. John Commission's vision for a bayou rich in recreation, the years following the Second World War witnessed a slow decline in its use for this purpose—perhaps in keeping with national trends or perhaps because of the bayou's poor ecological state in the decades leading up to the millennium. In 2005, Hurricane Katrina proved to be a catalyst in this respect, and the bayou has reemerged as a recreational hotspot. In 1950, however, where we pick up our story, the city appeared focused on renewed residential development, including along the bayou.

Subdivisions, Subdivisions

The decades after World War II witnessed profound social and physical changes in New Orleans, some resulting from national events, like *Brown v. Board of Education*, and others from more local phenomena, like 1965's Hurricane Betsy. Following the passing of the Federal Highway Act in 1956, New Orleans' major transportation arteries rose up in quick succession where canals or tree-lined avenues once stretched.[230] The bayou received its own fast-paced thoroughfare with the development of Wisner Boulevard along its western bank. The Wisner Boulevard Improvement and Beautification Project was meant to bring the bayou, roadway and park into a seamless embrace and to serve as a connection between the

Vehicles entering traffic circle near City Park from the newly paved Wisner Boulevard, circa 1940s to 1950s. *City Hall Slides Collection, Louisiana Division, New Orleans Public Library.*

Carrollton and Gentilly neighborhoods.[231] In 1950, the roadway opened as an unpaved, shell-topped boulevard; two years later, the city paved it with concrete once traffic had sufficiently packed the roadbed.[232]

Meanwhile, residential development along the entire length of the bayou increased exponentially after the war. From what was once swampy forest along the bayou's eastern edge, subdivisions leapt to life in what are now called the St. Bernard, Filmore and Lake Terrace neighborhoods.[233] The bayou itself was often factored into these developments. In order to serve the new Lake Terrace neighborhood, for example, the Sewerage and Water Board installed a subsurface, fifty-inch steel water main along Orleans Avenue, beneath the bayou and out Filmore Avenue to Franklin Avenue in 1954–55.[234] In 1953, the bayou's largest island was developed into twenty-eight residential lots and renamed Park Island.[235] Concurrent with this fast-paced development, and perhaps in response to it, public attitudes toward historical preservation began to shift. In 1950, the Louisiana Landmarks Society (LLS) was founded with the stated goal of preserving historically and architecturally important structures and spaces against incongruous development.[236] Beginning in the 1960s, the Louisiana Landmarks Society began including the Bayou St. John neighborhood in its walking tours,

signaling the beginning of a more formal awareness of the bayou's historic nature, particularly where it straddles Metairie Ridge.[237]

One of the LLS's most well-known feats of preservation got underway in 1964 and involved the property along the bayou owned by the Missionary Sisters of the Sacred Heart. In 1905, when the order acquired the tract of land between Esplanade Avenue and Moss Street, the property had two historic homes sitting on it. In 1964, in preparing to construct the Cabrini High School building currently occupying the site, the order needed the land under the homes but no longer had use for the buildings themselves.[238] In 1964, the order gave the society thirty days to salvage them. The LLS employed several tactics, including trying to get the two buildings listed as national monuments, but despite the organization's efforts, the smaller of the structures was demolished. The time it took to demolish the first house gave the LLS extra time to save the larger of the two, now known as the Pitot House. The Pitot House, named for its former owner and resident, James Pitot, remains one of the few extant French Creole–style plantation

Men laying a new water main beneath Bayou St. John, early 1950s. *Unattached Boards & Commissions, Sewerage and Water Board, Louisiana Division, New Orleans Public Library.*

Men laying a new water main beneath Bayou St. John, early 1950s. *Unattached Boards & Commissions, Sewerage and Water Board, Louisiana Division, New Orleans Public Library.*

City Councilman Walter M. Duffourc at DeSaix Bridge, circa 1940s to 1950s. *City Hall Slides Collection, Louisiana Division, New Orleans Public Library.*

houses in the city. The LLS managed to raise the funds required to move the house, and in June 1964, its careful dismantling began.[239] Over the course of the next ten years, despite multiple attacks from local vandals, Hurricane Betsy and fundraising challenges, the Pitot House underwent painstaking restoration and was opened to the public in 1973 at its new location at 1440 Moss Street.[240]

As for the waterway itself, the efforts of the Bayou St. John and City Park Commissions prior to the war had succeeded in thinning out larger craft and houseboats, even in the bayou's northern stretches. The Spanish Fort area, decades past its recreational heyday by 1950, still attracted small groups for picnics and other outings during the hot summer months.[241] Residents still frequented "Old Beach," where the Pontchartrain Beach Amusement Park once flourished, to catch sea breezes, fish or go swimming (although swimming access in the lake, including near its intersection with the bayou, was often restricted due to pollution over the decades following World War II). In 1956, a city ordinance declared it unlawful to swim or bathe in the bayou anywhere along its stretch.[242] General use of the bayou or its banks for recreational purposes was scant—a picnic or a stray swimmer here or there—until canoeing on the bayou became more popular in the 1970s.

The Pitot House at its original location, 1370 Moss Street. *Library of Congress.*

One potential factor in the bayou's lack of recreation during this era was that each spring, aquatic plants would choke the waterway, particularly south of Esplanade, spreading across its stretches like a carpet and often emitting an unpleasant odor. In a 1953 piece in the *Times-Picayune*, an upset resident described the bayou as an "optical liability" and a potential "menace to health."[243] Residents, together with the Bayou St. John Improvement Association—formed in the 1920s by residents concerned about the condition of the waterway—flooded city officials with complaints, suggestions and pleas for relief. Officials reassured residents that the bayou was not, in fact, unsafe and that the growth wasn't due to poor water quality. Nonetheless, some residents bemoaned that the growth happened each year because, as Edmond Villere told the *Times-Picayune* in 1952, "No city agency seems to have jurisdiction over the waterway. 'The bayou is a beautiful place…and no one seems to want to do anything to improve it. It's being left to rack and ruin.'"[244]

For years, nothing seemed to work to get rid of the weeds. City agencies tried just about everything: draining the bayou, dredging the bayou, pumping air into it to help dispel the odor, sending machines in to slash the weeds beneath the water's surface.[245] Most residents and experts believed that increased circulation would resolve the problem. The locks at either

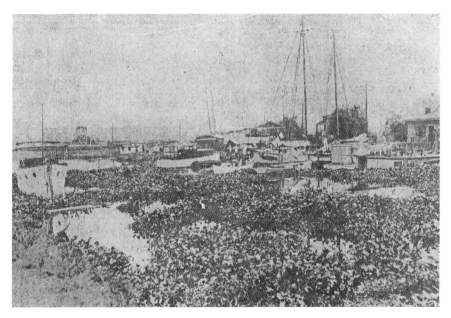

A 1922 *Times-Picayune* image of water hyacinths choking the bayou. *Archival newspaper image courtesy of J.S. Makkos/Nola DNA.*

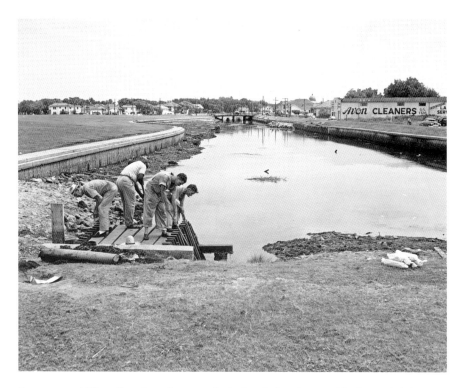

Sewerage and Water Board employees at the lock at Lafitte Avenue. The bayou is being drained for cleaning, early 1950s. *Unattached Boards & Commissions, Sewerage and Water Board, Louisiana Division, New Orleans Public Library.*

end of the bayou installed over the previous decades to control water level and to protect against storm surge, operated by the Sewerage and Water Board and the Orleans Levee Board, were either not maintained efficiently or proved largely ineffectual. Invasive, exotic water plants remained an issue (and remain an issue throughout the region today), particularly in bodies of water that are very fresh; given this, circulation may have had an impact on bayou growth since brackish water from Lake Pontchartrain was flowing only minimally into the bayou at the time.[246]

While recreation on the bayou's waters may have been sporadic at best, historical appreciation for the area was growing deeper by the day. Moreover, the city's sense of discrete neighborhoods, in part through a raised awareness of history and preservation, also began to crystallize.[247] According to the *Times-Picayune*, the Bayou St. John neighborhood in the 1970s was beginning to attract younger families: "The park is the neighborhood's playground, the bayou its scenic views….There

This page: Sewerage and Water Board employees hosing down bed of the bayou, early 1950s. *Unattached Boards & Commissions, Sewerage and Water Board, Louisiana Division, New Orleans Public Library.*

are stabilizers everywhere—the bayou and the park, the church, the schools, the wide thoroughfares—all influencing values and encouraging improvements."[248] Ten years later, in 1985, the *Times-Picayune* once again described the changes that had been taking place in the neighborhood:

> *During the past five to 10 years, doctors, lawyers, architects and executives have been moving into the area that includes strips of Mid-City and stretches into the Bayou St. John area. They are renovating old homes, splashing on bright colors. They are out jogging or canoeing on Bayou St. John or feeding ducks in City Park.…Those who live there say the revival…is for several reasons: availability of appealing, often historic houses at lower prices than Uptown; what's perceived as a homey, relatively crime-free atmosphere; abundant greenery; a hub location that provides easy access to the Central Business District, the French Quarter, Metairie, and Lake Pontchartrain.*[249]

Although young professionals were moving in from elsewhere, the Bayou St. John neighborhood also maintained strong nativity rates throughout the 1970s, '80s and '90s, a fact that remains true of the neighborhood today.[250]

Around this time, the phrase "Faubourg St. John" began to be used, at least sporadically, to describe the neighborhood to the east of the bayou's southern stretches—a resurrection of both the name and basic geographic area of Daniel Clark Jr.'s proposed neighborhood over 150 years earlier. The name would continue to gain popularity. According to Campanella, "[The term] *faubourg* was revived in the 1970s through the efforts of preservationists, neighborhood organizations, and real estate agents.…The term is now commonly used as a synonym for 'historic neighborhood' throughout New Orleans."[251] This neighborhood, the oldest along the bayou's banks, is also the only one along its stretches to claim the word *faubourg* in its title. In 1977, the Faubourg St. John Neighborhood Association was formed, and it has come to be known as one of the most active and organized neighborhood associations in the city, often collaborating with other nearby neighborhood groups, like the Lakeview Civic Improvement Association and the Mid-City Neighborhood Organization, to facilitate improvements in the neighborhood and along the bayou.[252] It was the Bayou St. John Improvement Association, however, that organized to fight the Levee Board's 1979 proposal to construct a grade-level roadway across the bayou at its intersection with Lake Pontchartrain.

Roadway vs. High-Rise

When it comes to Bayou St. John, the conflict that perhaps most defined the latter half of the twentieth century involved the tension between cost-effective flood protection and adequate circulation between the bayou and the lake. In order to prevent the bayou from becoming a storm-surge highway during weather events—shooting water straight into the city's heart—the Orleans Levee Board, charged with flood protection in Orleans Parish, had been searching for flood protection solutions since the early 1900s. In 1962, the Orleans Levee Board built a dam-like structure across the bayou at Robert E. Lee. It consisted of valve-controlled culverts and a recirculation system built to resemble a waterfall, which would later become infamous for its contribution to the bayou's decades-long struggle with stagnation. It was constructed to replace a set of locks built nearby in the 1930s, but this structure had not improved circulation either. By the 1960s, it had deteriorated to a pair of rusty gates, stuck partially open at a roughly forty-five-degree angle.[253] Meanwhile, to the north, a twin span allowed for uninterrupted travel along Lakeshore Drive. When this high-rise bridge fell into disrepair at the end of the 1970s, the Levee Board, with time and cost in mind, sprang into action to enact a plan to seal off the bayou from the lake forever.[254]

In 1979, the Orleans Levee Board announced plans to construct a grade-level roadway-plus-levee combination across the bayou at Lakeshore Drive. The roadway would have involved a massive earthen fill, as well as culverts, roadway embankments, levees and a seawall. It would have covered an area about 530 feet long and 280 feet wide. The bayou's water would have had to travel through culverts hundreds of feet long to reach the lake—and vice versa—assuming these culverts didn't get clogged with sediment or other organic matter. With this plan, the Levee Board could avoid rebuilding a costly bridge as well as all future levee maintenance along the bayou from its mouth to its head. But ecologists and bayou residents, backed by neighborhood groups and various elected officials, strongly opposed the roadway, often referred to simply as "the dam," and demanded that the bridge be repaired or rebuilt as a high-rise. Even though the Levee Board promised proper circulation of the bayou's waters, many residents were deeply skeptical that the culverts would allow for it, given the effects of the structure at Robert E. Lee.[255]

Resident Sidney L. Villere dramatically evoked the bayou's historic navigability as a reason to oppose the proposed roadway in the *Times-Picayune* in 1979:

In the desire to pursue their environmental nightmare by cutting asunder
Bayou St. John from Lake Pontchartrain, the Orleans Levee Board…failed
to consider the impact the operation would mean to the citizens of Orleans
Parish as to the legacy which was viewed and exploited by our founding
fathers when they colonized Louisiana in 1699.[256]

Other residents likened the severed bayou of the future with Bayou
Metairie, now a series of isolated lagoons in City Park, forever "lost to
history."[257] Mayor Dutch Morial summed up what was at stake: "Although
the waterway is now closed off at Robert E. Lee [by the 1962 flood control
structure], a total closing of the opening at Lake Pontchartrain would
forever preclude any future plans which could reopen this scenic and historic
channel."[258] By May 1979, once it was clear that money from the state to
repair the bridge was not going to arrive, the lakeshore bridge was closed for
good with the fate of the bayou beneath hanging in the balance.[259]

The Bayou St. John Improvement Association (BSJIA) began its long
fight to oppose the Levee Board's roadway almost immediately. Beginning
in 1980, President Raymond Boudreaux, alongside fellow BSJIA member
Benjamin Erlanger, did extensive research to attempt to get the bayou
placed in the National Register of Historic Places.[260] Boudreaux learned
this strategy's potential payoff when he spearheaded opposition to the
proposed Riverfront Expressway in the 1960s.[261] The Riverfront Expressway
would have slashed across the French Quarter along the riverfront if the
neighborhood hadn't been successfully listed in the National Register of
Historic Places in 1966.[262] Nonetheless, in early 1981, the Levee Board began
construction of the grade-level roadway at the bayou's intersection with the
lake.[263] Right away, the BSJIA filed a federal lawsuit against the Orleans
Levee Board, claiming that "the road project will harm the appearance of
the ancient bayou and diminish property values."[264] A federal judge upheld
a temporary ban on the roadway's construction in May 1981.[265]

On July 23, 1982, Acting Keeper of the National Register of Historic
Places Carol Shull wrote of the bayou's application:

Although Bayou St. John is definable and has well-documented historic
associations with patterns of events important to the early history of New
Orleans, the bayou is not eligible for inclusion in the National Register for
several reasons. The associations have not been linked with specific existing
portions of the bayou; no manmade traces of significant historic activities
remain; and historic integrity has been lost through continual, including

recent, alterations to and destruction of the historic character of the bayou and its setting.[266]

Shull also mentioned that "large bodies of water" were not typically included in the register. However, in July, 1982, the Louisiana legislature voted to add the bayou to the State Scenic Rivers System, administered by the Department of Wildlife and Fisheries, as a "historic and scenic river." According to the 1982 act:

"Historic and scenic river" means a river, stream, or bayou or segment thereof which because of its unique historical status and scenic character requires protection and preservation of its aesthetic, scenic, recreation, fish, wildlife, ecological, archaeological, geological, botanical, and other natural and physical features.[267]

While there are over sixty streams in the State Scenic Rivers System, only two have been given the extra designation of historic: Bayou Manchac and Bayou St. John. Barring existing exemptions, these streams would be afforded all the same protections. Any activity, development or other changes proposed to the bayou, if deemed potentially damaging to the bayou in a direct or significant way, would be subject to regulation and review by the Department of Wildlife and Fisheries and other state departments.[268]

Given that the bayou did not make it in the National Register, however, Judge Edward S. Boyle Sr. lifted most of the temporary ban he had issued in September 1982. The managing director of the Levee Board estimated that work on the roadway would begin within a month but reassured residents that the Levee Board would work closely with the Department of Wildlife and Fisheries throughout the process. In the meantime, the BSJIA had appealed the Keeper of the National Register's decision not to accept Bayou St. John. In 1982, Boudreaux received yet another rejection letter from the National Register staff. The bayou, although portions of it were deemed historically significant, was not determined to be historically significant as a whole unit.[269]

Then, for reasons that weren't entirely clear, even to the BSJIA, the Orleans Levee Board revealed that it had decided against the grade-level roadway at Lakeshore Drive. Sources suggest that perhaps they had simply tired of the public's resistance to the project.[270] In March 1983, the Levee Board met with neighborhood groups, the City Park Commission and representatives of the Department of Wildlife and Fisheries to offer plans

for a separate flood-control structure and a high-rise bridge to replace the one that had spanned the bayou. All present unanimously approved a flood-control proposal for a set of sector gates a few hundred feet south from the new bridge, originally designed to close only during potential storm-surge events.[271] The combination would provide unobstructed entry to the bayou as well as flood protection, and initially, the Levee Board agreed that the gates would remain open except during hurricane season.[272]

However, within only a few short years, tension grew over what the Levee Board had initially promised with the sector gates and what appeared to be the reality. In a 1984 report of the Levee Board's proposed project, the gates were planned to be "opened for operational checks" but otherwise would remain closed. (Instead, water would flow through two culverts thirty-six inches in diameter.) Once these new gates were built, the report claimed that the waterfall dam at Robert E. Lee would be removed, something for which neighborhood groups had long hoped.[273] By 1989, the twin-span at Lakeshore Drive was finally completed. Just to the south, the hinged floodgates were completed in 1992 and, until 2014, were closed except for operational checks, as the 1984 report had suggested. Both projects had been delayed several years by financial hang-ups and the Levee Board's focus on other lakefront flood protection projects. The dam at Robert E. Lee, contrary to what the Levee Board had promised, was not removed until 2014.[274]

In a 1988 letter to the president of the Levee Board, Louisiana House Representative "Peppi" Bruneau scolded:

> *I have reviewed the memo…relative to the proposed sector gate the mouth of Bayou St. John. It is obvious…that false representations were made to neighborhood citizens, civic organizations, and the Secretary of Wildlife and Fisheries. When the sector gate was discussed, we were assured by your engineering consultant…and your engineer…that the gate would remain open except during hurricane season in summer and late fall. As you are aware Bayou St. John is on the Scenic and Historic Rivers System, and any construction is subject to approval of the Secretary of the Department of Wildlife & Fisheries.….I strongly protest this charade that has been foisted upon the people of this area. I call on you and the Levee Board to take prompt and immediate action to insure that Bayou St. John will remain a free-flowing stream.[275]*

The debate surrounding operation of the gates, however, would not be resolved for another twenty-six years.

In the years leading up to the devastation of 2005's Hurricane Katrina, the bayou is remembered by many area residents to have been little more than a glorified dumping ground for cars and other refuse, generally regarded as unsafe because it was unused.[276] While residents may have occasionally enjoyed it for fishing or other activities, it was not considered by most to be an active recreational site.[277] Community cleanups—facilitated by the FSJNA in collaboration with city sanitation services, local volunteers and businesses—would often result in truckloads of debris being hauled from the waterway.[278] The same issue that had been plaguing the bayou for close to a century remained true: various agencies, although given jurisdiction of various kinds over various places on and along the bayou (City Park, the Sewerage and Water Board, the Orleans Levee Board, the Department of Wildlife and Fisheries and so forth) either denied the authority to clean it up or were hesitant to invest in its maintenance unless the others would agree to join in. On one of the community cleanup days in 1984, State Representative Leo Watermeier reported to the *Times-Picayune*, "Nobody cleans it....When we tried to find out who was responsible by contacting different agencies, they all denied having jurisdiction over the water itself."[279]

These issues would reemerge after Hurricane Katrina wrought havoc in 2005. While the storm changed much about the city, it only served to strengthen the connection between New Orleans residents and the bayou. The bayou's centrality to the city's sense of identity, as evidenced by the doggedness of area residents to protect and preserve it, remained just as true after the storm.

HURRICANE KATRINA

As Hurricane Katrina bore down on New Orleans in August 2005, the city's navigation and outfall canals proved to be most vulnerable.[280] As Campanella explains it:

> *Sometime Monday, possibly even before Katrina arrived but certainly by late morning, a breach developed on the Orleans Parish side of the 17th Street Canal levee in Lakeview....The three-hundred-foot opening sent a turbulent plume of brackish water exclusively into the Orleans Parish basin.*

The middle-class early twentieth-century suburb of Lakeview flooded first and most violently, even as Katrina's fiercest winds roared overhead. Mid-City and other below-sea-level areas on the East Bank followed.[281]

Given this and the other levee breaches to follow, Campanella continues, "Citizens remaining lakeside of roughly the St. Charles/Rampart/St. Claude corridor (historically the 'back of town'), with the minor exception of the Metairie/Gentilly Ridge and the man-made lakefront, were forced to their steamy attics or boiling rooftops to await rescue by air or boat."[282] The gaping breach in the 17th Street Canal, which affected the bayou area most directly, could not be closed, even when helicopters dropped bags of sand to try to staunch the flow. In the immediate aftermath of the storm, a strip of high ground near the bayou's base morphed into an emergency helicopter pad in an effort to save stranded residents.[283]

In the weeks and months to follow, life around the bayou remained anything but normal. Floodwaters had inundated the waterway itself, as well as City Park, Mid-City, Lakeview and Gentilly via breaches in the 17th Street and Orleans Canals, resulting in close to ten feet of floodwater in some places.[284] Once it had been pumped out, the bayou's sluice gates at

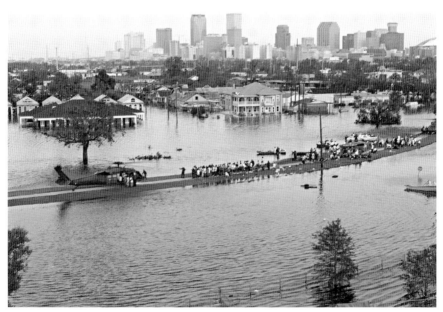

City residents awaiting rescue along a strip of high ground bordering Bayou St. John. Image taken on afternoon of Wednesday, August 31, 2005, from the rooftop of the American Can Company building. *Courtesy Jonathan Traviesa, © Traviesa, 2005.*

Robert E. Lee, which had been closed before the storm, remained closed for two months, turning the bayou into a low-water, high-salinity field of debris. City Park had been all but devastated, losing over two thousand trees, many of which were ancient live oaks.[285] Schools in many neighborhoods were closed for months or never reopened.[286]

Nonetheless, the city began to rebuild, including the neighborhoods along Bayou St. John. The waterway itself received new attention as well: a collaboration between numerous experts and organizations, the Bayou St. John Comprehensive Management Plan was born in late 2006. The document sought to provide "a guide to manage and improve the bayou [that] may be utilized by jurisdictional agencies, nonprofits, civic organizations and any other interested individual or group."[287] One of its major highlights was a proposal to remove once and for all the 1962 flood-control structure at Robert E. Lee Boulevard. The document provides a snapshot of recreation along the bayou in the year or two following the storm. Aside from huge neighborhood cleanups, the authors mention Super Sunday, the Greek Festival, Beach Sweep and caroling by canoes in December. One of the document's primary goals, aside from increasing "recreational access and use of Bayou St. John," was to facilitate formal agreement between various agencies with jurisdiction over the waterbody, in order to create clarity around bayou management and thereby improve its estuarine and ecological conditions.[288]

In the decade following the storm, the questions of whether the 1992 sector gates near the mouth of the bayou ought to be opened—and at what frequency—only grew more urgent. For the Army Corps of Engineers and the Southeast Louisiana Flood Protection Authority–East (the regional flood protection entity put in place in lieu of the Orleans Levee Board in 2006), the one and only concern on the heels of the storm remained flood control. Once again, the Army Corps and Levee Board considered sealing off the mouth of the bayou permanently. Once again, residents, scientists, businesses and other public and nonprofit groups felt that the issue should be more than about simply preventing storm surge. Why couldn't the gates remain open until hurricane season, as the Levee Board had initially promised, thereby increasing circulation in a stagnant bayou? And why couldn't the old dam at Robert E. Lee be removed once and for all if the other gates were functioning?

For these citizens, preserving the bayou's ancient connection to the lake was crucial—for both ecological and historical reasons—even after the unprecedented devastation of the city's levee system following the storm.

And yet, for the SLFPA-E, funding the efficient operation of the sector gates, all the while managing flow and salinity from the lake, was a tall order.[289] Subsidence along with rising sea levels mean that the city is now below the level of the bayou, which is below the level of the lake. This was not always the case. Whereas flow between the bayou and the lake used to occur in both directions, the bayou no longer serves as a drainage conduit for the surrounding landscape. Since water flows only from the lake into the bayou, improved circulation without overtopping the bayou's levees is much more difficult than it once was.[290]

As recently as 2008, an ad hoc system in which City Park representatives and other informal watchdogs monitored the bayou's water level and reported to the Levee District when issues arose was still in place; no formal chain of command in relation to the bayou's water level existed. As usual, the bayou's multiple layers of jurisdiction hindered a decision on the operation of the sector gates from being made right away. The Army Corps of Engineers had gained responsibility of the sector gates, but oversight of the water and the gates more broadly (both the new and old structures) fell to the SLFPA-E. City Park controlled the west bank of the waterway from Robert E. Lee to the Magnolia Bridge, and the Sewerage and Water Board took over from there to the bayou's terminus. Funding, of course, was also a huge part of it: the Levee District estimated that at least four or five people would need to be devoted to the working of the sector gates, plus the cost of operating the gates themselves, which would mean multiple agencies would have to come together to make it happen. However, in 2008, nineteen businesses, as well as neighborhood and environmental groups, signed a resolution to look into opening the sector gates more often, as well as removing the old flood-control structure at Robert E. Lee. To them, a free-flowing bayou smelled and looked better, had more economic potential, could support a larger number and variety of aquatic species and furthermore reflected the bayou's natural and historic essence.[291]

Eventually, a collaboration between the Orleans Levee District, the Louisiana Sea Grant, various aquatic ecologists and the engineering firm Burk-Kleinpeter Inc. resulted in possibly in one of the most momentous transformations (or restorations) to occur to the waterway over the course of its human history. By 2014, the old flood-control structure at Robert E. Lee had been removed. The mouth of the bayou was dredged and the extra sediment used to create a foundation for new "urban wetlands" on Bayou St. John, near where it meets Lake Pontchartrain, as envisioned by wetland biologist Andrew Baker and the Lake Pontchartrain Basin Foundation.[292]

While connectivity between the two bodies of water could never be fully restored, periodic opening of the gates by the Levee Board (for roughly thirty to forty-five minutes per month, when the water level in the bayou is naturally low) has allowed, scientists believe, for greater ecological activity in the waterway. The hope is the wetlands will attract some of the aquatic species that once called this portion of the Lake Pontchartrain shoreline home and that, when the gates are opened, at least a few of them will swim or scuttle through to live on the other side.[293] As the *NOLA Defender* reported in 2014, "Scientists hope[d] that oxygen, aquatic vegetation, and pregnant fish [would] make their way up the bayou from the lake and populate it with a new regime of life."[294]

The Old Basin's relict pathway got a post-Katrina makeover, too. The nonprofit Friends of the Lafitte Greenway formed a few months after Hurricane Katrina, founded by a group of residents who were concerned with the direction citywide revitalization efforts, particularly in relation to green space, were taking. Their efforts have resulted in a 2.6-mile "green corridor" called the Lafitte Greenway, opened in 2015, complete with a

Bayou St. John Urban Wetlands and high-rise bridge along Lakeshore Drive, looking toward Lake Pontchartrain, 2017. *Photo by author.*

Sector gates near bayou's intersection with Lake Pontchartrain, now opened occasionally to increase water flow between both waterbodies, 2017. *Photo by author.*

Former site of waterfall flood control structure at Robert E. Lee Boulevard, 2017. *Photo by author.*

bicycle and pedestrian trail, fields for recreation, new trees, native plant meadows and storm water management infrastructure. The corridor, managed by the city's recreation department, stretches along the right-of-way the Old Basin Canal originally traveled from the bayou to the French Quarter. Development along the corridor—commercial, residential and recreational—continues as of this writing.[295]

In the years following the storm, the bayou underwent what might be described as a recreational metamorphosis. The ensuing tension between public use and preservation is still unfolding. Some residents credit Jared Zeller of the MotherShip Foundation, founder of the Mid-City Bayou Boogaloo annual music festival on the banks of the bayou, for setting the recreational "tone" after the storm. His vision was to start a free and inclusive music festival that would give back to the community as a way of revitalizing nearby neighborhoods. The first festival in 2006 brought around five thousand festival-goers to the bayou's western bank near Orleans Avenue; 2016's Bayou Boogaloo, after ten years of increasing popularity, brought around thirty-eight thousand.[296] The festival invests in planting new live oak trees along this stretch of bank (some of the largest oak trees ever planted in the city) to replace those that died during Hurricane Katrina and subsequent storms. Proceeds from the festival have also gone to local neighborhood groups, toward promoting anti-litter initiatives along the waterway and facilitating public art projects.[297] Bayou Boogaloo is just one way in which the bayou is currently used for recreation. On any given day, kayakers, paddle-boarders, picnickers, volleyball players, canoodling lovers and families can be seen gracing the waters, the banks and the cement wharves along the bayou. Other festivals and public events abound. The bayou has become one of the city's primary recreation spots, and many residents regard this increased recreational energy as reason for the bayou's general renaissance: with use, comes stewardship.

And yet, some residents in the area feel that recreational use of the bayou has perhaps become too much of a good thing. Concerns about noise, litter and inappropriate parking abound. Some residents feel that homeownership along the bayou's banks ought to result in greater say in the use of those banks, particularly if homeowners are left with the task of cleanup and upkeep. Other residents view the bayou and its banks as a public asset, the use of which ought to be decided by the public. Still others are concerned that the bayou's recreational potential will be exploited by out-of-town commercial interests, resulting in things like retail strips, jet skis, gentrification, ecological degradation and, paradoxically, a decrease in

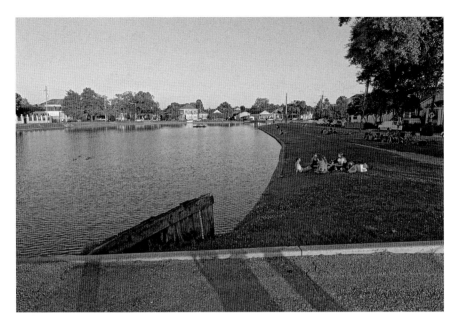

A typical day along Bayou St. John, 2017. *Photo by author.*

public access to the bayou. The vast majority seem to fit in somewhere in the middle: that increased recreation along the bayou is a good thing, but noise and litter associated with large public events ought to be regulated or accounted for.[298] Today, the recreational balance of the bayou's banks remains in question, but love for the bayou across the city, among longtime residents and post-Katrina newcomers alike, continues unabated.

BAYOU OF THE FUTURE

In the introduction to this book, I described the bayou of today from the vantage point of Moss Street and Esplanade Avenue: cyclists and kayakers, swimming dogs and picnickers, ducks and shoreline greenery. But what if we were to imagine Bayou St. John of the future from this intersection? As we move through a world increasingly affected by climate change, in a city already plagued with decades' worth of subsidence, the bayou has a potentially crucial role to play in the more sustainable New Orleans of the future. Many scientists and researchers agree: the city has to find a way to live *with* water, instead of in opposition to water, if it hopes to survive. If progress

in the past was measured by the city's ability to pump water out as quickly as possible and to hide from sight the immense infrastructure charged with doing so, then progress of the future must necessarily be measured by both intimacy with, and increased public access to, that very same water. With that intimacy, a new kind of adaptive control would be born.

For example, the Greater New Orleans Urban Water Plan, researched and written by the firm Waggonner and Ball Architects in collaboration with local and international experts in 2013, cites the bayou as a prime example of one of the ways the city might adapt:[299]

> *The Urban Water Plan proposes the restoration of the city's canals to prominence as historic water corridors, each of which provides the city's residents with access to new water-based amenities in the form of blueways, greenways, water plazas, and parklands. For a region built on a river and an estuary and created out of swamp, water is remarkably hard to find. Except for Bayou St. John and the beloved lakes and lagoons of Lafreniere Park, Audubon Park, City Park, Joe Brown Park, and Sidney Torres Park, most of the region's canals and other waterways provide little value as spaces for public life.[300]*

Bayou St. John is cited time and time again in the plan as a prime example of water being framed as a public asset in the present day—as a way of returning to the relationship New Orleans' citizens once had with their own waterways. The plan cites houseboats on the bayou and fishing camps on Lake Pontchartrain as examples of the ways in which New Orleanians used to interact with these bodies of water, before flood protection and other visions of progress created boundaries between them and the public.[301] In the mid-twentieth century, canals were either filled in or buried, one after the next.[302] The Urban Water Plan suggests uncovering, un-walling and beautifying some of these canals so that "waterways across the region can become places for public life, supporting reinvestment and development by bringing people and commerce to the water's edge. Complementing the river, seafood, and jazz—regional cultural icons—Greater New Orleans can become known as a place of great waterways and waterfronts."[303] The Lafitte Blueway, a resurrection of the Old Basin Canal, for example, was also proposed in the plan.

If the Lafitte Blueway were to course along what is now the Lafitte Greenway (coexisting, theoretically, with the Greenway development already put in place), it would operate within an integrated system of canal

networks, lakes and wetlands. Surface water would be circulated and used to replenish groundwater during dry weather and to increase drainage during wet weather.[304] The bayou, already an example of "flow restoration" thanks to recent efforts to reconnect the waterway with Lake Pontchartrain, would serve as a central conduit within this canal network. The plan explains, "Water flowing through Bayou St. John cascades down into the Blueway, and serves as a source of water for circulating canal networks in the city's bowls. This improves local soil stability and limits subsidence."[305]

So, if you were to stand at the intersection of Moss and Esplanade, say, thirty-five years in the future, what might you see? If we assume aspects of the Urban Water Plan, or a similar plan, will have been enacted by then, perhaps climbing a tree would once again be helpful: at the bayou's current terminus at Lafitte Avenue, roughly south of you, the water would not, in fact, terminate. Instead, the bayou would swing to the east, as it once did, and course along what is now the Lafitte Greenway—still peppered with fields of native grasses, spaces for recreation and other multiuse features already in place along the corridor. Along the Blueway, people may be playing volleyball or soccer; picnickers may lounge along the canal's edge. Cyclists and pedestrians would create a steady stream of traffic between the bayou and the French Quarter, and a variety of new businesses would have sprung up along the corridor to serve them. Perhaps, a bit farther north along the bayou's bank, you might be able to see a portion of the Orleans Canal, sub-surfaced in the 1950s, re-exposed to the air.[306] Along all three visible waterways, recreation would be spread evenly. You would be surrounded by blue, green and the bright rainbow of colors New Orleanians love to paint their houses. And all around you, from where you sit in your leafy perch, the city would hum with life.

NOTES

Introduction

1. Bishop, *Complete Poems*, 169.
2. Ibid., 101.

Chapter 1

3. Campanella, *Bienville's Dilemma*, 77.
4. Ibid.; Freiberg, *Bayou St. John*, 3; "Wisconsin Glacial Stage," Encyclopedia Britannica, accessed May 29, 2017, http://www.britannica.com/science/Wisconsin-Glacial-Stage; Gupta, *Large Rivers*, 65; Powell, *Accidental City*, 5.
5. Campanella, *Bienville's Dilemma*, 77–80.
6. Powell, *Accidental City*, 5.
7. Ward, "Ecology," 3–5; Campanella, *Bienville's Dilemma*, 78, 80–81; Campanella, *Geographies of New Orleans*, 57.
8. Saucier, *Recent Geomorphic History*, 68, 72; Ward, "Ecology," 5.
9. Ward, "Ecology," 5; Saucier, *Recent Geomorphic History*, 70–72; Campanella, *Geographies of New Orleans*, 57.
10. Freiberg, *Bayou St. John*, 3.
11. Saucier, *Recent Geomorphic History*, 8.
12. Campanella, *Geographies of New Orleans*, 59.
13. Saucier, *Recent Geomorphic History*, 68, 72; Campanella, *Geographies of New Orleans*, 58–59.

14. Ward, "Ecology," 5.

15. Freiberg, *Bayou St. John*, 5.

16. Ward, "Ecology," 5–9; Kidder, "Making the City Inevitable," 17.

17. Powell, *Accidental City*, 7.

18. Freiberg, *Bayou St. John*, 6–9; Saucier, *Recent Geomorphic History*, 91.

19. Campanella, *Geographies of New Orleans*, 59; Ward, "Ecology," 5–9.

20. Campanella, *Geographies of New Orleans*, 59.

21. Ferguson, "Overview," 39; Campanella, *Bienville's Dilemma*, 100; Kniffen, Gregory and Stokes, *Historic Indian Tribes*, 5.

22. Kniffen, Gregory and Stokes, *Historic Indian Tribes*, 4; Giardino, "Documentary Evidence," 240–41.

23. Kidder, "Making the City Inevitable," 19.

24. Ibid.

25. McIntire, *Prehistoric Indian Settlements*, 12–13; Gagliano, "Geoarchaeology," 26.

26. Gagliano, "Geoarchaeology," 27.

27. Saucier, *Recent Geomorphic History*, 32.

28. Kidder, "Making the City Inevitable," 16.

29. Ibid., 14–15.

30. Nathanael Heller, in discussion with author, June 2017.

31. Ibid.

32. Campanella, *Bienville's Dilemma*, 99.

33. Saucier, *Recent Geomorphic History*, 33, 35; Gagliano, "Geoarchaeology," 35–36.

34. Usner, "American Indians," 164.

35. Gagliano, "Geoarchaeology," 36–37.

36. McIntire, *Prehistoric Indian Settlements*, 19, 23–24; Kidder, "Rat that Ate Louisiana," 146–47, 159–160; Gagliano, "Geoarchaeology," 36–37.

37. Saucier, *Recent Geomorphic History*, 33–34.

38. Usner, "American Indians," 164.

39. Campanella, *Bienville's Dilemma*, 79.

40. "FEMA Archaeologists Discover One of the Oldest Native American Artifacts South of Lake Pontchartrain," Department of Homeland Security, accessed May 29, 2017, http://www.fema.gov/news-release/2013/02/20/fema-archaeologists-discover-one-oldest-native-american-artifacts-south-lake.

41. Ibid.

42. McGimsey, "Marksville," 132.

43. Heller, discussion.

44. Kidder, "Making the City Inevitable," 19.

45. Usner, "American Indians," 164–65.

46. Norman Nail, in discussion with author, May 2017.

47. Campanella, *Bienville's Dilemma*, 101.

48. Ibid., 101.

49. Ibid.

50. Freiberg, *Bayou St. John*, 19–20; Kniffen, Gregory and Stokes, *Historic Indian Tribes*, 21–22; Du Pratz, *History of Louisiana*, chapter 4.

Chapter 2

51. Bourgmont, "Exact Descriptions of Louisiana," 11.

52. Ibid.

53. Powell, *Accidental City*, 8.

54. McWilliams, introduction, 4.

55. Midlo Hall, *Africans in Colonial Louisiana*, 2.

56. Iberville, *Iberville's Gulf Journals*, 57.

57. Du Ru, *Journal*, 16.

58. Powell, *Accidental City*, 44; Campanella, *Bienville's Dilemma*, 107.

59. Johnson, "Colonial New Orleans," 31; Usner, *Indians, Settlers & Slaves*, 16–18.

60. Freiberg, *Bayou St. John*, 44.

61. Powell, *Accidental City*, 44–45; Campanella, *Bienville's Dilemma*, 20–21.

62. Powell, *Accidental City*, 43, 58.

63. Ibid., 53; Campanella, *Bienville's Dilemma*, 20.

64. Du Pratz, *History of Louisiana*, foreword.

65. Ibid., chapter 4.

66. Ibid., chapter 5.

67. Ibid.

68. Ibid., foreword.

69. Powell, *Accidental City*, 55.

70. Ibid., 72.

71. Ibid., 72–74, 222; Midlo Hall, *Africans in Colonial Louisiana*, 126–28.

72. Freiberg, *Bayou St. John*, 42.

73. Caillot, *Company Man*, 83.

74. Freiberg, *Bayou St. John*, 45.

75. Ibid., 56, 61–62.

76. Ibid., 163.

77. Van Zante, *New Orleans 1867*, 113.
78. Ibid., 41, 54.
79. Toledano and Christovich, *New Orleans Architecture*, xi; Powell, *Accidental City*, 65.
80. Usner, *Indians, Settlers & Slaves*, 54–55.
81. Ibid., 7, 55; Johnson, *Congo Square*, 10.
82. Johnson, "Colonial New Orleans," 39–40.
83. Usner, *Indians, Settlers & Slaves*, 63; Johnson, *Congo Square*, 10.
84. Toledano and Christovich, *New Orleans Architecture*, 56.
85. Freiberg, *Bayou St. John*, 72, 81.
86. Ibid., 64–65.
87. Caillot, *Company Man*, 134.
88. Ibid., 134–35.
89. Ibid., 82.
90. Freiberg, *Bayou St. John*, 99.
91. Caillot, *Company Man*, 135.
92. Ibid., 82, 84.
93. Ibid., 135–37.
94. Gordon, "Journal," 484.
95. Powell, *Accidental City*, 165, 228–31.
96. Midlo Hall, "Formation of Afro-Creole Culture," 78.
97. Ibid., 79.
98. Freiberg, *Bayou St. John*, 234; Midlo Hall, *Africans in Colonial Louisiana*, 202.
99. Midlo Hall, "Formation of Afro-Creole Culture," 79–80.
100. Powell, *Accidental City*, 272.
101. Freiberg, *Bayou St. John*, 205.
102. Ibid., 154.
103. Ibid., 153, 163.
104. Ibid., 198–99.
105. Powell, *Accidental City*, 143, 177, 188.
106. Ibid., 208–9; Freiberg, *Bayou St. John*, 279.
107. Freiberg, *Bayou St. John*, 298–99; Douglas, *Public Spaces, Private Gardens*, 39.
108. Farrell, "New Orleans Canals."
109. Powell, *Accidental City*, 206; Douglas, *Public Spaces, Private Gardens*, 39; Freiberg, *Bayou St. John*, 302.

Chapter 3

110. Campanella, *Bienville's Dilemma*, 26, 200.

111. Crosby, "Ownership of Navigable Waterbottoms," 695.

112. Hollier, "Civil Law Property," 463–64.

113. Mark Davis, in discussion with author, May 2017.

114. Powell, *Accidental City*, 314–18.

115. Campanella, *Bienville's Dilemma*, 161.

116. Paxton, *New-Orleans Directory*, 36.

117. Lachance, "Foreign French," 104; Wilson, *Pitot House*, 15–16; Douglas, *Public Spaces, Private Gardens*, 40.

118. Hirsch and Logsdon, introduction, 92–93; Campanella, *Geographies*, 211–13.

119. Campanella, *Bienville's Dilemma*, 163.

120. Ibid., 201–2.

121. Powell, *Accidental City*, 346–47.

122. "The Extension of the City," *Times-Picayune*, September 9, 1854.

123. Campanella, *Bienville's Dilemma*, 313.

124. Campanella, *Geographies*, 92–94; Louisiana Landmarks Society, *Bayou St. John*; Urban Alexander, *Notorious Woman*, 4.

125. Gehman, *Free People of Color*, 52.

126. Campanella, *Bienville's Dilemma*, 30.

127. Ibid., 178.

128. Campanella, *Geographies*, 215; Toledano and Christovich, *New Orleans Architecture*, xv–xvi.

129. Douglas, *Public Spaces, Private Gardens*, 42.

130. *Times-Picayune*, July 4, 1841.

131. Ripley, *Social Life in Old New Orleans*, 63.

132. Norvell, "Spanish Fort"; Douglas, *Public Spaces, Private Gardens*, 42; wall text, "Bayou St. John and the Carondelet Canal: Interconnections of History," curated by Louis W. McFaul, Louisiana Landmarks Society Pitot House. This information accompanied an exhibit no longer on display at the Pitot House.

133. Twain, *Life on the Mississippi*, 312.

134. "Women Lighthouse Keepers," U.S. Coast Guard, accessed June 3, 2017, https://www.uscg.mil/history/uscghist/Women_Keepers.asp.

135. "Historic Light Station Information & Photography: Louisiana," U.S. Coast Guard, accessed June 2, 2017, http://www.uscg.mil/history/weblighthouses/lhla.asp; Norvell, "Spanish Fort."

136. "Annual Entertainment of the St. John Rowing Club," *Times-Picayune*, May 7, 1875.

137. Douglas, *Public Spaces, Private Gardens*, 43.

138. Ashe, *Travels in America*, 275.

139. Douglas, *Public Spaces, Private Gardens*, 73–76.

140. Powell, *Accidental City*, 335.

141. Van Zante, *New Orleans 1867*, 107.

142. Campanella, *Bienville's Dilemma*, 214.

143. Ibid., 30.

144. Farrell, "New Orleans Canals"; Campanella, *Bienville's Dilemma*, 31.

145. Campanella, *Bienville's Dilemma*, 135, 209.

146. Gilbert Shaw to parents, 1862–63.

147. "Park Island," *Times-Picayune*, May 3, 1987; Reeves, Reeves, Laborde and Janssen, *Historic City Park*, 89.

148. Douglas, *Public Spaces, Private Gardens*, 76.

149. Fandrich, *Mysterious Voodoo Queen*. Fandrich uses the spelling "Laveaux" in this work; the author has chosen to use the most common spelling of the name, "Laveau."

150. Ibid., 127.

151. Sublette, *World that Made New Orleans*, 285.

152. "St. John's Eve. Decline and Fall of Marie Levaux's Worship—The True Inwardness of Latter," *Times-Picayune*, June 25, 1877.

153. Ibid.

154. Fandrich, *Mysterious Voodoo Queen*, 199.

155. Ibid., 148.

156. "The Environs of New Orleans," *New Orleans Daily Crescent*, May 9, 1866, accessed June 4, 2017, http://chroniclingamerica.loc.gov/lccn/sn82015753/1866-05-09/ed-1/seq-4.

157. Ibid.

158. Ibid.

159. Ibid.

160. Campanella, *Bienville's Dilemma*, 219–22.

161. "Squares and Streets in the Rear of the City," *Times-Picayune*, October 10, 1851.

162. Boyko et al., *Phase I Archaeological Inventory*, 31–53.

163. Cole, "New Orleans City Park."

164. Reeves, Reeves, Laborde and Janssen, *Historic City Park*, 12.

165. "The City Park Has Made Fine Progress," *Daily Picayune*, September 4, 1900.

166. Boyko et al., *Phase I Archaeological Inventory*, 31–53.

Chapter 4

167. Campanella, *Bienville's Dilemma*, 43–44; *Times-Picayune*, June 12, 1921.

168. Boyko et al., *Phase I Archaeological Inventory*, 54–56.

169. "The History of City Park," *The Herald*, May 1, 1913.

170. Widmer, *New Orleans*, 72.

171. Glenn Gaudet, "Location of 1st Pontchartrain Beach Compared to Location of Spanish Fort Amusement Park," e-mail message to author, September 13, 2016.

172. *WPA Guide to New Orleans*, 294; Widmer, *New Orleans in the Thirties*, 68.

173. Campanella, *Bienville's Dilemma*, 224.

174. Ibid., 39.

175. "Captain Pizzati's Gift Gift Creates Enthusiasm," *Times-Picayune*, June 25, 1904.

176. "Our Cabrini Legacy," Cabrini High School, accessed January 2, 2017, http://www.cabrinihigh.com/aboutcabrini/cabrinilegacy.

177. Campanella, *Geographies*, 315, 332.

178. "Canals Bringing Business Here," *Times-Picayune*, September 1, 1903.

179. "Beautifying the Bayou after Bridge Is Built," *Times-Picayune*, August 2, 1906.

180. Campanella, *Time and Place*, 67.

181. "Louisiana Loses Fight for Canal in U.S. Court," *Times-Picayune*, April 21, 1914.

182. Reeves, Reeves, Laborde and Janssen, *Historic City Park*, 92.

183. "Boat Owners Fight to Keep Canal Open: They Claim Bayou St. John Is a Natural," *Times-Picayune*, July 11, 1908.

184. Ibid.

185. "Bayou St. John. Carondelet Canal Company Charged with Obstructing It," *Times-Picayune*, September 13, 1908.

186. Ibid.

187. "The Open Court," *Times-Picayune*, March 19, 1909.

188. "Bayou St. John," *Times-Picayune*, June 22, 1913.

189. Ibid.

190. "Supreme Court Gives Control of Bayou St. John to State," *Times-Picayune*, June 26, 1910; "Louisiana Loses Fight."

191. "Louisiana Loses Fight." The author currently cannot reconcile the discrepancy between the information regarding Bayou St. John's legal standing in the 1920s in Reeves, Reeves, Laborde and Janssen, *Historic City Park New Orleans*, and the other sources listed regarding *The State vs.*

CCNC. Interested readers and researchers should refer to Reeves, Reeves, Laborde and Janssen, 93.

192. Readers interested in learning more about the valuation process of the waterway, plus details surrounding who had a stake in its determination, should read "Carondelet Canal's Value Put at $300,000," *Times-Picayune*, April 3, 1921.

193. "State Must Wait Until 1916 to Buy City Waterway," *Times-Picayune*, July 3, 1914; "Old Basin's Price to State $300,000," March 24, 1921.

194. "Owners of Boats in Bayou St. John Must Pay Tolls," *Times-Picayune*, April 29, 1914.

195. Ibid.

196. "City Park Board Is for Removal of Boathouses," *Times-Picayune*, May 2, 1914.

197. Davis, discussion.

198. Campanella, *Bienville's Dilemma*, 46.

199. "City Pays $75,000 to Canal Company," *Times-Picayune*, February 10, 1925.

200. "Company Willing to Clean Canals; Carondelet Concern Asks to Be Given Time by State Board," *Times-Picayune*, July 18, 1922; "Purchase of Canal Is Urged on State," *Times-Picayune*, October 6, 1921.

201. "Engineer Seeks Facts on Traffic," *Times-Picayune*, November 9, 1922; Reeves, Reeves, Laborde and Janssen, *Historic City Park*, 92.

202. "Citizens Asked to Help Beautify City Park," *Times-Picayune*, July 11, 1920.

203. "Old Bayou St. John Could Be Easily Made Beauty Spot," *Times-Picayune*, September 25, 1921.

204. Ibid.

205. "Canal and Bayou Called Nuisances; Steps to Force Cleaning of Waterways Taken at Meeting," *Times-Picayune*, July 11, 1922.

206. Boyko et al., *Phase I Archaeological Inventory*, 62.

207. "Bayou St. John to Be Beautified," *New Orleans States*, December 2, 1926.

208. Ibid.

209. "Asks US to Take Hand in Battle Against Squatters," *New Orleans States*, January 6, 1927.

210. "Protests Permit for Boat Houses," *New Orleans States*, January 12, 1927.

211. Ibid.

212. "Bayou Dwellers Get Health Notices," *Times-Picayune*, January 19, 1927.

213. "Park Island."

214. Reeves, Reeves, Laborde and Janssen, *Historic City Park*, 95.

215. Ibid.

216. Ibid.

217. Ibid.

218. Ibid., *Historic City Park*, 95; City Engineer's Bridge Records.

219. U.S. Congress, House of Representatives, Mr. Maloney, *Bayou St. John*.

220. Davis, discussion.

221. Reeves, Reeves, Laborde and Janssen, *Historic City Park*, 95–96.

222. Campanella, *Bienville's Dilemma*, 223.

223. Ibid., 224.

224. Ibid.

225. Ibid., 48–49.

226. Altobello, *New Orleans*, xvii.

227. Strahan, *Andrew Jackson Higgins*, 123–24.

228. Reeves, Reeves, Laborde and Janssen, *Historic City Park*, 96.

229. Read, "Family-Owned New Orleans Grocery."

Chapter 5

230. Campanella, *Bienville's Dilemma*, 52.

231. City Engineer's Bridge Records.

232. "New Wisner Blvd. Open Wednesday," *Times-Picayune*, July 11, 1950; "Wisner Project Dedication Held," *Times-Picayune*, June 9, 1952.

233. Swenson, "How Do We Map"; "Local Population Trends," *Times-Picayune*, September 1, 1951.

234. "Lakefront Area Project Okayed," *Times-Picayune*, April 9, 1954.

235. "Island in Bayou St. John to Have 28 Sites," *Times-Picayune*, April 5, 1953.

236. Campanella, *Bienville's Dilemma*, 50.

237. "Bayou St. John Spots on Tour," *Times-Picayune*, April 13, 1963.

238. Historic American Buildings Survey, *Michel-Pitot House*.

239. "Landmark Razing to Begin," *Times-Picayune*, June 17, 1964.

240. "Pitot House Is Living Museum of Early 19th Century Years," *Times-Picayune*, November 18, 1973.

241. *Times-Picayune*, June 11, 1950.

242. City of New Orleans, "Article II.—Boat and Water Safety."

243. "The Bayou—Again," *Times-Picayune*, June 25, 1953.

244. "Bayou St. John Acting Up Again," *Times-Picayune*, June 21, 1952.

245. Schleifstein, "Algae, Plants, Choke."

246. Andy Baker, in discussion with the author, May 2017; John Lopez, in discussion with author, May 2017; Schroeder, "Exchange Flows."

247. Campanella, *Bienville's Dilemma*, 57.

248. Schneider, "Renewed Interest."

249. Treadway, "Migration."

250. Conrad Abadie, in discussion with author, August 2015.

251. Campanella, *Bienville's Dilemma*, 289.

252. "About," Faubourg St. John Neighborhood Association, accessed May, 2017. http://fsjna.org/about.

253. Raymond Boudreaux, in discussion with author, April 2017; Lake Pontchartrain Basin Foundation, "Bayou St. John Comprehensive Management Plan," 5–6; Thomas A. Sands, District Engineer, to Mr. Louis S. Wall, Chief of Western Office of Review and Compliance, March 30, 1979.

254. Bill Calder, interview with Larry Baudet, chief engineer Orleans Levee Board, *WWL 8700*.

255. Sands, District Engineer, *Findings of Fact*; Bayou St. John Improvement Association, "The Future of Bayou St. John," 2–1.

256. Villere, "Save Bayou St. John."

257. Boudreaux, "Bayou St. John Improvement," 1982.

258. Ibid.

259. Citron, "Levee Board."

260. Boudreaux, discussion.

261. Ibid.

262. Ibid.

263. Montaigne, "Lakeshore Span Work."

264. Hardy, "Citizen Group."

265. Gsell, "Bayou St. John Bridge."

266. Carol D. Shull, Acting Keeper of the National Register, to Robert E. DeBilieux, July 23, 1982.

267. H.R. 384 (1982) (enacted).

268. Matthew Weigel, in discussion with author, May 2017.

269. Russell B. Long, United States Senate, to Raymond P. Boudreaux, September 30, 1982.

270. Boudreaux, discussion.

271. Schroeder, "Exchange Flows," 1.

272. Raymond J. Boudreaux, "Preservation," 1–2; Emile "Peppi" Bruneau Jr., House of Representatives, to Steven O. Medo Jr., President Board of Levee Commissioners, June 24, 1988.

273. Pepper and Associates, Inc., "Class B Permit Request," 1–9.

274. Anderson, "Floodgate Receives"; Lake Pontchartrain Basin Foundation, "Bayou St. John Comprehensive Management Plan," 4, 7–8.

275. Bruneau Jr. to Medo Jr.

276. Peter Hickman, in discussion with author, April 2017; Jared Zeller, in discussion with author, May 2017; Abadie, discussion; Cullen Landry, in discussion with author, 2016; Jessie Borrello, in discussion with author, September 2015; Anthony Favre, in discussion with author, 2016.

277. Joan Ellen Young, in discussion with author, May 2017.

278. Gloria Martin, in discussion with author, May 2017.

279. Landis, "Volunteers Get Muck."

280. Campanella, *Bienville's Dilemma*, 66.

281. Campanella, *Geographies*, 389.

282. Ibid.

283. Ibid.; MacCash, "Jonathan Traviesa."

284. MacCash and O'Byrne, "Levee Breach Floods."

285. "City Park History," New Orleans City Park, accessed May 2, 2017, http://neworleanscitypark.com/new-orleans-city-park-history.

286. Lake Pontchartrain Basin Foundation, "Bayou St. John Comprehensive Management Plan," 7.

287. Ibid., v.

288. Ibid., 15.

289. Reid, "Officials Call Bayou."

290. Baker, discussion; Lopez, discussion.

291. Reid, "Officials Call Bayou."

292. Baker, discussion.

293. Ibid.; Lopez, discussion.

294. Staudinger, "Please Stand Bayou."

295. "About," Friends of Lafitte Greenway, accessed May 2, 2017, http://www.lafittegreenway.org/aboutfolc.

296. Hickman, discussion; MacCash, "Did You Bayou Boogaloo?"; Spera, "2016 Bayou Boogaloo."

297. Zeller, discussion; "Home," MotherShip Foundation, accessed May 2, 2017, https://mothershipfoundation.wordpress.com.

298. Staudinger, "Democracy on the Bayou"; Young, discussion; Martin, discussion.

299. "About," Greater New Orleans Urban Water Plan, accessed June 4, 2017, http://livingwithwater.com/blog/urban_water_plan/about.

300. Waggonner & Ball Architects, *Urban Water Plan*, 34.

301. Ibid., 70.
302. Farrell, "New Orleans Canals."
303. Waggonner & Ball Architects, *Urban Water Plan*, 72.
304. Ibid., 108–10.
305. Ibid., 109.
306. Farrell, "New Orleans Canals."

SELECTED BIBLIOGRAPHY

Altobello, Brian. *New Orleans Goes to War, 1941–1945: An Oral History of New Orleans during World War II*. N.p.: 1990.

American Association of Port Authorities. "Getting Back to Basics: The U.S. Government's Historic Role in Developing and Maintaining Landside and Waterside Connections to Seaports." Accessed January 2, 2017. http://aapa.files.cms-plus.com/PDFs/Transportation%20and%20 the%20Constitution1.pdf.

Anderson, Ed. "Floodgate Receives Levee Board OK." *Times-Picayune*, September 25, 1986.

Ashe, Thomas. *Travels in America, Performed in 1806, for the Purpose of Exploring the Rivers Allegheny, Monongahela, Ohio and Mississippi and Ascertaining the Produce and Condition of Their Banks and Vicinity.* London: Phillips, 1808.

Banks, Musa. "Guest Column: In Support of a Greener Bayou St. John." *Mid-City Messenger*, February 25, 2014. http://midcitymessenger. com/2014/02/25/guest-column-in-support-of-a-greener-bayou-st-john.

Bayou St. John Historic Homes Tour. New Orleans: Louisiana Landmarks Society, 1986.

Bayou St. John Improvement Association. "The Future of Bayou St. John." Unpublished report, New Orleans, January 25, 1982.

Bishop, Elizabeth. *The Complete Poems, 1927–1979*. New York: Farrar, Straus and Giroux, 1979.

Boudreaux, Raymond. "Bayou St. John Improvement Association Newsletter." 1982. Personal collection of Raymond Boudreaux.

———. "Preservation" (presentation, undated). Personal collection of Raymond Boudreaux.

Bourgmont, Étienne de Veniard, Sieur de. "Exact Descriptions of Louisiana." Translated by Mrs. Max W. Myers. Edited by Marcel Giraud, 11. *The Missouri Historical Society Bulletin* 15 (October 1958): 3–19. Accessed April 30, 2016. www.americanjourneys.org/aj-093.

Boyko, Wayne C.J., Susan Barrett Smith, Kelly Sellers Wittie, Jill Adams, Dena Struchtmeyer, Allison Flanagan, Amy Mann, Ashley S. Hale, Tyler Leben, Reagan Buckley, Nathanael Heller, Katy Coyle, Kathleem M. Child, Katie L. Kosack, William P. Barse, Thea Stehlik-Barry and William P. Athens. *Phase I Archaeological Inventory of Portions of New Orleans City Park and Phase II Testing and Evaluation of Sites 16OR626 and 16OR19 in New Orleans, Orleans Parish, Louisiana*, 31–56; 62. New Orleans, LA: R. Christopher Goodwin and Associates Inc., 2013.

Bruneau, Emile "Peppi," Jr., House of Representatives, to Steven O. Medo Jr., President Board of Levee Commissioners, June 24, 1988.

Caillot, Marc-Antoine. *A Company Man: The Remarkable French-Atlantic Voyage of a Clark for the Company of the Indies*. Edited by Erin M. Greenwald and translated by Teri F. Chalmers, 83; 134–35. New Orleans, LA: Historic New Orleans Collection, 2013.

Calder, Bill. Interview with Larry Baudet, chief engineer Orleans Levee Board. *WWL 8700*. Radio show, December 20, 1981.

Campanella, Richard. *Bienville's Dilemma: A Historical Geography of New Orleans.* Lafayette: University of Louisiana at Lafayette, 2008.

———. *Geographies of New Orleans: Urban Fabrics Before the Storm.* Lafayette: University of Louisiana at Lafayette, 2006.

———. *Time and Place in New Orleans: Past Geographies in the Present Day.* Gretna, LA: Pelican Publishing, 2002.

Citron, Alan. "Levee Board Will Close Lakeshore Drive Bridge." *Times-Picayune*, May 15, 1979.

City Engineer's Bridge Records, 1918–1967. City Archives. Louisiana Division, New Orleans Public Library.

City of New Orleans. "Article I.—In General." Accessed June 2, 2017. https://www.municode.com/library/la/new_orleans/codes/code_of_ordinances?nodeId=PTIICO_CH170WA_ARTIINGE_S170-3STNOBEERETBASTJO.

———. "Article II.—Boat and Water Safety." Accessed June 2, 2017. https://www.municode.com/library/la/new_orleans/codes/code_of_

ordinances?nodeId=PTIICO_CH170WA_ARTIIBOWASA_S170-61SWPRBASTJO.

Cole, Catharine. "New Orleans City Park: A Bit of History as to What It Was in Olden." *Times-Picayune*, March 13, 1892.

Crosby, Francis J. "Ownership of Navigable Waterbottoms—California Co. v. Price Revisited." *Louisiana Law Review* 36, no. 2 (Winter 1976): 694–704.

Douglas, Lake. *Public Spaces, Private Gardens: A History of Designed Landscapes in New Orleans*. Baton Rouge: Louisiana State University Press, 2011.

Du Pratz, Le Page. *History of Louisiana, Or of the Western Parts of Virginia and Carolina*. Paris, 1758. Kindle edition.

Du Ru, Paul. *Journal of Paul du Ru: February 1 to May 8, 1700 Missionary Priest of Louisiana*. Edited by Ruth Latham Butler. Chicago: Caxton Club, 1934.

Evans Reeves, Sally K., William D. Reeves, Ellis P. Laborde and James S. Janssen. *Historic City Park New Orleans*. New Orleans, LA: Friends of City Park, 1982.

Fandrich, Ina Johanna. *The Mysterious Voodoo Queen, Marie Laveaux: A Study of Powerful Female Leadership in Nineteenth-Century New Orleans*. New York: Taylor & Francis Group, 2005.

Farrell, Diane. "New Orleans Canals Go Underground." *Times-Picayune*, February 12, 1950.

Federal Writers' Project Guide to 1930s New Orleans. *WPA Guide to New Orleans*. Boston: Houghton Mifflin, 1938.

Ferguson, Robert. "An Overview of Southeastern Indian Culture." In *Indians of the Lower South: Past and Present*, edited by John K. Mahon, 39. Pensacola, FL: Gulf Coast History and Humanities Conference, 1975.

Freiberg, Edna. *Bayou St. John in Colonial Louisiana 1699–1803*. New Orleans, LA: Harvey Press, 1980.

Gagliano, Sherwood M. "Geoarchaeology of the Northern Gulf Shore." In *Perspectives on Gulf Coast Prehistory*, edited by Dave D. Davis, 27; 35–37. Gainesville: University of Florida Press/Florida State Museum, 1984.

Gehman, Mary. *The Free People of Color of New Orleans: An Introduction*. New Orleans, LA: Margaret Media Inc., 1994.

Giardino, Marco J. "Documentary Evidence for the Location of Historic Indian Villages in the Mississippi Delta." In *Perspectives on Gulf Coast Prehistory*, edited by Dave D. Davis, 240–41. Gainesville: University of Florida Press/Florida State Museum, 1984.

Gordon, Captain Harry. "Journal of Captain Harry Gordon's Journey from Pittsburgh down the Ohio and the Mississippi to New Orleans, Mobile, and Pensacola, 1766." In *Travels in the American Colonies*, contributors

Newton Dennison Merriness and the National Society of the Colonial Dames of America, 484. New York: Macmillan, 1916.

Gsell, Gordon. "Bayou St. John Bridge Could Hurt Marine Life." *Times-Picayune*, May 8, 1981.

Gupta, Avijit, ed. *Large Rivers: Geomorphology and Management.* Leeds: School of Geography, University of Leeds, 2007.

Hardy, Jeannette. "Citizen Group Sues to Halt Replacement of Lakefront Bridge." *Times-Picayune*, April 11, 1981.

Hasselle, Delia. "Greener Bayou St. John Coalition Group Contemplates Floating Plant 'Islands,' Testing Fish." *Mid-City Messenger*, March 14, 2014.

————. "Neighborhood Groups Ask for More Transparency from Greener Bayou St. John Coalition." *Mid-City Messenger*, April 8, 2014.

Hirsch, Arnold R., and Joseph Logsdon. Introduction to Part II "The American Challenge." In *Creole New Orleans: Race and Americanization*, edited by Arnold R. Hirsch and Joseph Logsdon, 92–93. Baton Rouge: Louisiana State University Press, 1992.

Historic American Buildings Survey. *Michel-Pitot House, 1370 Moss Street Moved to 1440 Moss Street, New Orleans, Orleans Parish, LA.* Photograph. New Orleans, Louisiana, https://www.loc.gov/item/la0061.

Hollier, William C. "Civil Law Property—Beds of Navigable Waters—Susceptibility of Private Ownership." *Louisiana Law Review* 15, no. 2 (1955). Accessed June 2, 2017. http://digitalcommons.law.lsu.edu/lalrev/vol15/iss2/34.

Iberville, Pierre Le Moyne, Sieur d'. *Iberville's Gulf Journals.* Translated and edited by Richebourg Gaillard McWilliams. Tuscaloosa: University of Alabama Press, 1981.

Johnson, Jerah. "Colonial New Orleans: A Fragment of the Eighteenth-Century French Ethos." In *Creole New Orleans: Race and Americanization*, edited by Arnold R. Hirsch and Joseph Logsdon, 31; 39–40. Baton Rouge: Louisiana State University Press, 1992.

————. *Congo Square in New Orleans.* New Orleans: Louisiana Landmarks Society, 1995.

Kidder, Tristram R. "Making the City Inevitable: Native Americans and the Geography of New Orleans." In *Transforming New Orleans and Its Environs: Centuries of Change*, edited by Craig E. Colten, 16–17; 19. Pittsburgh: University of Pittsburgh Press, 2000.

————. "The Rat that Ate Louisiana: Aspects of Historical Ecology in the Mississippi River Delta." In *Advances in Historical Ecology*, edited by William Balee, 146–47; 159–60. New York: Columbia University Press, 1998.

Kniffen, Fred. B., Hiram F. Gregory and George A. Stokes. *The Historic Indian Tribes of Louisiana*. Baton Rouge: Louisiana State University Press, 1987.

Lachance, Paul F. "The Foreign French." In *Creole New Orleans: Race and Americanization*, edited by Arnold R. Hirsch and Joseph Logsdon, 104. Baton Rouge: Louisiana State University Press, 1992.

Lake Pontchartrain Basin Foundation. "Bayou St. John Comprehensive Management Plan." New Orleans, 2006. http://saveourlake.org/wp-content/uploads/PDF-Documents/habitat/BSJ_CMP.pdf.

Landis, Dylan. "Volunteers Get Muck for Efforts." *Times-Picayune*, August 12, 1984.

Long, Russell B., United States Senate, to Raymond P. Boudreaux, September 30, 1982.

MacCash, Doug. "Did You Bayou Boogaloo? What Changes Do You Suggest?" *Times-Picayune*, May 23, 2016.

———. "Jonathan Traviesa Keeps His Lens Focused on Changing New Orleans: Katrina and the Arts." *Times-Picayune*, August 24, 2015.

MacCash, Doug, and James O'Byrne. "Levee Breach Floods Lakeview, Mid-City, Carrollton, Gentilly, City Park." *Times-Picayune*, August 30, 2005.

McGimsey, Charles R. "Marksville and the Middle Woodland." In *Archaeology of Louisiana*, edited by Mark A. Rees. Baton Rouge: Louisiana State University Press, 2010.

McIntire, William G. *Prehistoric Indian Settlements of the Changing Mississippi River Delta*. Baton Rouge: Louisiana State University Press, 1958.

McWilliams, Tennant S. Introduction to *Iberville's Gulf Journals*, translated and edited by Richebourg Gaillard McWilliams, 4. Tuscaloosa: University of Alabama Press, 1981.

Midlo Hall, Gwendolyn. *Africans in Colonial Louisiana: The Development of Afro-Creole Culture in the Eighteenth Century*. Baton Rouge: Louisiana State University Press, 1992.

———. "The Formation of Afro-Creole Culture." In *Creole New Orleans: Race and Americanization*, edited by Arnold R. Hirsch and Joseph Logsdon, 78–80. Baton Rouge: Louisiana State University Press, 1992.

Montaigne, Fen. "Lakeshore Span Work Is Set to Begin May 1." *Times-Picayune*, March 19, 1981.

Norvell, Lillian S. "Spanish Fort in Retrospect." *Times-Picayune*, June 25, 1911.

Paxton, John Adems. *The New-Orleans Directory and Register*. New Orleans, LA: Benjamin Levy & Co., 1822–23.

Pepper and Associates Inc. "Class B Permit Request for Orleans Levee

District Project No. 2001, Mid-Rise Bridge and Sector Gates for Bayou St. John Flood Protection Plan at Lake Shore Drive." January 1984. Personal collection of Raymond Boudreaux.

Powell, Lawrence H. *The Accidental City*. Cambridge, MA: Harvard University Press, 2012.

Read, Mimi. "Family-Owned New Orleans Grocery Celebrates 90 Years, Four Generations." *The Advocate*, April 20, 2015. Accessed June 2, 2017. http://www.theadvocate.com/new_orleans/news/article_d5f2d5f4-7d2c-5ed7-aece-c79c03fcd58e.html.

Reid, Molly. "Officials Call Bayou St. John a Flood Protection Liability, but New Orleanians Call It a 'Treasure.'" *Times-Picayune*, December 26, 2008.

Ripley, Eliza. *Social Life in Old New Orleans: Being Recollections of My Girlhood*. New Orleans, LA: Cornerstone Book Publishers, 2012.

Sands, Thomas A. *Findings of Fact—Board of Levee Commissioners*. New Orleans, LA: Department of the Army, 1980. Personal collection of Raymond Boudreaux.

Sands, Thomas A., District Engineer, to Mr. Louis S. Wall, Chief of Western Office of Review and Compliance, March 30, 1979. Personal collection of Raymond Boudreaux.

Saucier, Roger T. *Recent Geomorphic History of the Pontchartrain Basin*. Baton Rouge: Louisiana State University Press, 1963.

Schleifstein, Mark. "Algae, Plants, Choke Bayou St. John; Residents Complain." *Times-Picayune*, June 13, 1984.

Schneider, Frank L. "Renewed Interest in Old Neighborhood by the Green and Blue." *Times-Picayune*, January 5, 1975.

Schroeder, Robin L. "Exchange Flows in an Urban Water Body: Bayou St. John Responded to the Removal of Flood Control Structures, Future Water Elevation Control, and Water Quality." Thesis, University of New Orleans, 2011.

Shaw, Gilbert, to parents, New Orleans, LA, 1862–1863. Gilbert Shaw Letters, MSS 278, Williams Research Center, Historic New Orleans Collection, New Orleans.

Shull, Carol D., Acting Keeper of the National Register, to Robert E. DeBilieux, July 23, 1982. Personal collection of Raymond Boudreaux.

Spera, Keith. "2016 Bayou Boogaloo Rated a Success Despite Fence Controversy and Theft of $6,000 from VIP Bar." *New Orleans Advocate*, May 24, 2016. Accessed June 2, 2017. http://www.theadvocate.com/new_orleans/news/article_ea55647a-ed41-57b8-bc8d-2aae23a5f5be.html.

Staudinger, Christopher. "Democracy on the Bayou: Residents Debate Uses of Bayou St. John, Talk Master Plan." *NOLA Defender.* Accessed May 29, 2017. http://www.noladefender.com/content/democracy-bayou.

——————. "Please Stand Bayou, Group to Bayou St. John: Just Act Natural." *NOLA Defender.* Accessed May 29, 2017. http://www.noladefender.com/content/please-stand-bayou.

Strahan, Jerry E. *Andrew Jackson Higgins and the Boats that Won World War II.* Baton Rouge: Louisiana State University Press, 1994.

Sublette, Ned. *The World that Made New Orleans: From Spanish Silver to Congo Square.* Chicago: Lawrence Hill Books, 2008.

Swenson, Dan. "How Do We Map New Orleans? Let Us Count the Ways." *Times-Picayune*, April 23, 2015.

Toledano, Roulhac, and Mary Louise Christovich. *New Orleans Architecture.* Vol. 6, *Faubourg Tremé and the Bayou Road.* Gretna, LA: Pelican Publishing Company, 1980.

Treadway, Joan. "Migration: Yuppies Down Near the Bayou." *Times-Picayune*, March 17, 1985.

Twain, Mark. *Life on the Mississippi.* New York: Harper and Brothers Publishers, 1901.

Urban Alexander, Elizabeth. *Notorious Woman: The Celebrated Case of Myra Clark Gaines.* Baton Rouge: Louisiana State University Press, 2001.

U.S. Congress, House of Representatives, Mr. Maloney, from the Committee on InterState and Foreign Commerce. *Declaring Bayou St. John, in New Orleans, LA., A Nonnavigable Stream: Report (to Accompany H. R. 11792).* 74th Cong., 2d sess., 1936, H. Rep. 2629.

Usner, Daniel H., Jr. "American Indians in Colonial New Orleans." In *Powhatan's Mantle: Indians in the Colonial Southeast*, edited by Gregory A. Waselkov, Peter H. Wood and Tom Hatley, 164–65. Lincoln: University of Nebraska Press, 2006.

——————. *Indians, Settlers & Slaves in a Frontier Exchange Economy: The Lower Mississippi Valley Before 1783.* Chapel Hill: University of North Carolina Press, 1992.

Van Zante, Gary A. *New Orleans 1867: Photographs by Theodore Lilienthal.* London: Merrell Publishers Limited, 2008.

Villere, Sydney. "Save Bayou St. John." *Times-Picayune*, April 18, 1979.

Waggonner & Ball Architects. *Greater New Orleans Urban Water Plan.* New Orleans: Waggonner & Ball Architects, 2013. Accessed June 4, 2017. https://dl.dropboxuser content.com/content_link/dWS3fKwaF38vSCkqWPWK9XUyL5JYrMqu0yVkA8ofyuNddZNcIUN3CVYNEYgWtNw/file.

Ward, Kathleen A. "Ecology of Bayou St. John: A Thesis." Master's thesis, University of New Orleans, 1982.

Widmer, Mary Lou. *New Orleans: 1900 to 1920.* Gretna, LA: Pelican Publishing Company, 2007.

―――. *New Orleans in the Thirties.* Gretna, LA: Pelican Publishing Company, 1980.

Wilson, Samuel, Jr. *The Pitot House on Bayou St. John.* New Orleans: Laborde Printing, 1992.

Wirt, John. "Post-Katrina's Bayou Boogaloo Is Now a Firmly Entrenched Mid-City Tradition." *New Orleans Advocate*, May 23, 2015. Accessed May 29, 2017. http://www.theadvocate.com/new_orleans/entertainment_life/music/article_9af473ed-38e0-5ed0-ad3a-2e064ad2009f.html.

INDEX

A

Almonester y Roxas, Andrew 45
Anglo-Americans/Anglophones
 50, 52
aquatic plants 98
Army Corps of Engineers 78, 84,
 85, 108

B

Baker, Andrew 109
Bart Davis, J. (Captain) 79
Basin Street 47
Bayou Boogaloo 112
Bayou Gentilly. *See* Bayou Sauvage
Bayou Manchac 35, 104
Bayou Metairie 16, 22, 24, 25, 33,
 66, 103
Bayou Road 33, 37, 39, 40, 41, 43,
 45, 47, 52, 53
Bayou Sauvage 16, 30, 31, 33, 34

Bayou St. John Commission 83,
 84, 93
Bayou St. John Comprehensive
 Management Plan 108
Bayou St. John Improvement
 Association 78, 98, 101, 103
Bayou St. John Light 56
Bayou St. John, Port of 37, 45
Bienville draining machine 65
Bienville, Jean-Baptiste Le Moyne,
 Sieur de 28, 29, 31, 34, 40,
 41
Bienville Street 65
Boudreaux, Raymond 103, 104
Bourgmont, Étienne de Veniard,
 Sieur de 27
Boyle, Edward S., Sr. (Judge) 104
Bruneau, Emile "Peppi" 105
Burk-Kleinpeter, Inc. 109

C

Cabrini High School 24, 74, 95
Cabrini, Mother Frances Xavier 73
Caillot, Marc-Antoine 34, 41, 42
Capdeville, Paul 71
Carondelet Canal. *See* Old Basin
 Canal
Carondelet Canal and Navigation
 Company 11, 51, 62, 76
Carondelet, Francisco Luis Hector,
 barón de (Governor) 40, 45,
 47
Chiapella, Henri (United States
 Commissioner) 79
City Park 15, 44, 55, 62, 65, 66, 71,
 78, 80, 83, 85, 101, 103, 106,
 107, 108, 109, 114
City Park Avenue 14, 32, 72, 90
City Park Commission 81, 83, 85,
 104
Civil War 57, 61, 62, 64, 65, 66
Clark, Daniel, Jr. 39, 50, 53
Company of the Indies 34, 35, 37,
 40, 41
Company of the West. *See*
 Company of the Indies
Congo Square 58, 62
Creole 43, 45, 51, 52, 53, 69, 95

D

Department of Wildlife and
 Fisheries 104, 105, 106
de Périer, Étienne Boucher
 (Governor) 40
DeSaix Avenue 35
de Soto, Hernando 18

Dreux, Mathurin and Pierre 34
Dubreuil, Claude Joseph Villars 35
du Pratz, Antoine-Simon Le Page
 24, 31, 32, 33
du Ru, Paul 29

E

Elysian Fields Avenue 59, 89
Erlanger, Benjamin 103
Esplanade Avenue 26, 37, 39, 47,
 53, 72, 73, 86, 91, 95, 113
Esplanade Bridge 69, 80, 84
Esplanade Ridge 15, 16, 29, 53, 66

F

Fairgrounds (neighborhood) 53
Faubourg Marigny 59, 66
Faubourg St. John 39, 50, 53, 101
Faubourg St. John Neighborhood
 Association 101
Filmore (neighborhood) 94
free people of color 43, 44
French Quarter 24, 30, 31, 33, 47,
 48, 52, 53, 66, 74, 101, 103,
 112, 115
Friends of the Lafitte Greenway 110

G

Gage, Annie 57
Gentilly 34, 53, 71, 92, 93, 107
Gordon, Harry (Captain) 42
Greater New Orleans Urban Water
 Plan 114, 115

Gulf of Mexico 13, 16, 22, 28, 29, 31

H

Higgins, Andrew Jackson 90
Higgins boats 90
houseboats 78, 80, 81, 83, 84, 86, 114
Hubert, Marc-Antoine 32
Hurricane Katrina 93, 106, 110, 112

I

Iberville, Pierre Le Moyne, Sieur de 24, 25, 28, 29
Industrial Canal 82, 89

J

Jefferson Davis Parkway 65
Jung, Andres 44

L

Lafitte Blueway 114
Lafitte Greenway 47
Lake Borgne 14
Lakefront Project 89
Lake Oaks 89
Lake Pontchartrain 14, 15, 16, 21, 24, 26, 29, 31, 34, 35, 40, 41, 42, 45, 47, 51, 53, 55, 56, 59, 61, 62, 63, 64, 65, 66, 70, 74, 78, 79, 80, 82, 83, 89, 90, 99, 101, 102, 103, 108, 109, 114, 115
Lake Pontchartrain Basin Foundation 109
Lakeshore Drive 89, 102, 104, 105
Lakeshore (neighborhood) 89
Lake Terrace 89, 94
Lakeview 53, 71, 92, 106, 107
Lakeview Civic Improvement Association 101
Lake Vista 89
Laveau, Marie 63
LeBreton Market 39
Levee Board (Orleans) 83
Lincoln Beach 73
Louis Armstrong Park 58
Louisiana Landmarks Society 51, 94, 95, 97
Louisiana Purchase 50, 52, 53
Louisiana Sea Grant 109

M

Magnolia Bridge 109
Manchac 31
maroons and *marronage* 43, 44, 62, 64
McDonogh, John 65
Metairie Ridge 16, 22, 24, 34, 45, 57, 95
Metairie Road 14, 24, 72
Metairie-Sauvage distributary 14, 15, 16, 17, 26
Mid-City 25, 66, 71, 92, 101, 107
Mid-City Neighborhood Organization 101
Milneburg 56, 61

Missionary Sisters of the Sacred Heart 73, 95
Mississippi River 14, 15, 16, 17, 18, 20, 21, 22, 26, 27, 28, 29, 32, 33, 42, 50, 56
Moss Street 26, 47, 74, 95, 113
MotherShip Foundation 112
Myra Clark Gaines 53

N

Natchez 32, 33
National Register of Historic Places 103, 104
Native Americans 18, 19, 21, 22, 24, 25, 28, 29, 30, 31, 32, 35, 37, 39, 41, 52
New Basin Canal 49, 61, 76
Nicholls, W.P. (Captain) 79
North Rampart Street 47, 53, 58

O

Old Basin Canal 47, 53, 55, 58, 59, 61, 71, 75, 76, 80, 82, 83, 86, 110, 112, 114
Orleans Avenue 94, 112
Orleans Canal 107, 115

P

Parker, Walter 82, 83, 84
Park Island 45, 62, 94
Pitot, James 51, 76, 95, 97
Place Bretonne 53
pleasure gardens 58

Pontchartrain Basin 18, 20, 21, 22
Pontchartrain Beach Amusement Park 73

R

Rivard, Antoine 31, 32, 35, 41
Riverfront Expressway 103
Rivers and Harbors Act of 1899 86
Robert E. Lee Boulevard 22, 102, 103, 105, 108, 109

S

Scenic Rivers System 104
17th Street Canal 106, 107
Sewerage & Water Board 81
Shaw, Gilbert 61, 62
shipyards 75, 78, 83, 84, 86, 90
Shull, Carol 103, 104
slaves and slavery 30, 31, 32, 33, 34, 35, 37, 40, 41, 43, 44, 45, 47, 49, 50, 52, 58, 63
Southeast Louisiana Flood Protection Authority—East 108, 109
Spanish Fort 22, 31, 55, 56, 79, 80, 85, 89
Spanish Fort Amusement Park 62, 73
St. Bernard (neighborhood) 94
St. John's Eve 63
St. Maxent, Gilbert Antoine de 45

U

United States Supreme Court 76,
 81
University of New Orleans 90

V

Vieux Carré. *See* French Quarter
voodoo 62, 63

W

Waggonner and Ball Architects 114
War Department. *See* Army Corps
 of Engineers
West End 56, 61
Wisner Boulevard 35, 45, 93
Wood, Albert Baldwin 65
Works Progress Administration 85
World War II 90, 93

Z

Zeller, Jared 112

ABOUT THE AUTHOR

Cassie Pruyn is a New Orleans–based writer and researcher, born and raised in Portland, Maine. She is the author of *Lena*, winner of the Walt McDonald First-Book Prize in Poetry (Texas Tech University Press, 2017). Her poems, reviews and essays have appeared in numerous publications. To read more of her work, including her blog about Bayou St. John, visit her website at cassiepruyn.com.

Visit us at
www.historypress.net